IMAGES
of America

MACON COUNTY

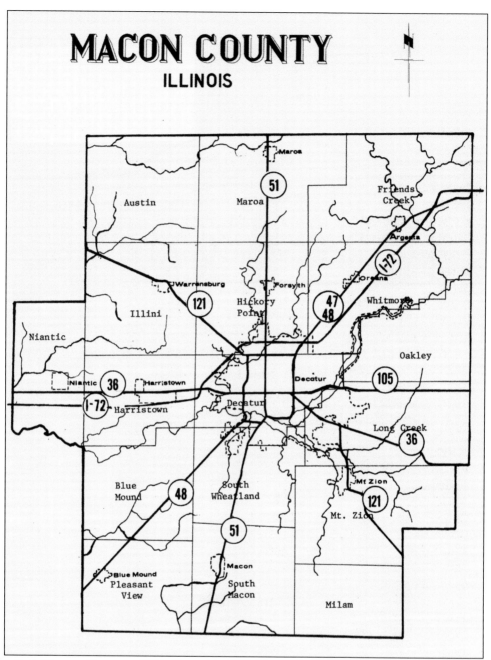

MACON COUNTY
ILLINOIS

MAP OF MACON COUNTY, 1976. Created in 1829, Macon County covers 585 square miles in the center of Illinois. Macon County is served by U.S. Highways 36 and 51, as well as Interstate 72. Fifteen towns and villages are located within its boundaries. (Courtesy of Decatur Public Library.)

On the cover: **THE TOPSYS.** On May 15, 1910, the YWCA basketball team, popularly known as the "Topsys," posed for this team photograph. From top to bottom and from left to right, they are Mary Leech, Mae Cannard, Rose Ruckle, Irene Chandler, Ruth Stephens, Flora Ellis, and Edna Cromer, the coach. (Courtesy of Decatur Public Library.)

IMAGES
of America

MACON COUNTY

Dan Guillory

ARCADIA
PUBLISHING

Published by Arcadia Publishing
Charleston, South Carolina

Printed in the United States of America

Library of Congress Catalog Card Number: 2006933893

For all general information contact Arcadia Publishing at:
Telephone 843-853-2070
Fax 843-853-0044
E-mail sales@arcadiapublishing.com
For customer service and orders:
Toll-Free 1-888-313-2665

Visit us on the Internet at www.arcadiapublishing.com

*To Leslie, Gayle, Carl, Lilly, Carleton,
Mary Lynn, Zoe, Tom, and Robin.*

CONTENTS

ACKNOWLEDGMENTS

Ann Marie Lonsdale, my editor at Arcadia Publishing, first proposed the idea for this book, and she continued to offer her generous support and encouragement throughout the project.

Lee Ann Fisher, city librarian of the Decatur Public Library, allowed me complete access to the holdings of the Shilling Local History Room. In addition, librarians Sandi Pointon, Bev Hackney, Arthur Gross, and Chris Sweet helped in a variety of ways, large and small, as did the local history volunteers, including Rosie Smith, Gary Reynolds, David Rush, Peggy Bergen, Doug Imboden, and Lou Robbins. Matt Wilkerson and Junie Longbons provided invaluable technical assistance.

Ann Adkesson, director of the Barclay Public Library in Warrensburg, graciously shared vintage photographs from the library collection and from her own family archive. Sandy Lynch and Rosemary Malone also provided many personal photographs and keepsakes as well as vintage pictures from the Forsyth/Hickory Point Township Historical Society. Jean Cunningham, director of the Forsyth Public Library, kindly allowed the use of the library for conferencing and also provided logistical assistance.

Pat Riley and Larry Nix deserve a special commendation for their kindness and cooperation in allowing me to use their rich collections of postcards, railroad and sports memorabilia, business cards, and Christmas cards. Since there is no central, public archive for Macon County materials, their private collections allowed all 15 of the towns, villages, and hamlets of Macon County to be represented in this book.

Thanks to Janet Nix for providing books on the Maroa centennial and sesquicentennial, to Nancy Torgerson for food data, to Dorothy Pugh for maps, and to Darren Eckart for images of Macon. I thank Pat McDaniel, executive director of the Macon County Historical Society Museum, for letting me search through their files, particularly old newspaper clippings on Macon County. I thank Brent Wielt of the Macon County Conservation District for materials on pioneer life. Finally, thanks to John Rotz for the horse racing photographs.

The people named above acted in the best cooperative traditions of the county. It was my privilege to work with all of them.

INTRODUCTION

After the last ice age, once the glaciers began to melt, the upper-Mississippi valley turned into a lush prairie dotted with lakes and marshes. At one time or another, mastodons, wolves, bison, and Woodland Indians made trails through the towering stalks of big bluestem, prairie dock, and other native plants. On high ridges and hillocks, stands of hardwoods thrived, including 15 species of oak, as well as walnut, hickory, ash, and maple. In the early 17th century, Fr. Jacques Marquette, the Jesuit explorer, drew a crude map of the area, indicating that the Maroa tribe occupied the area that is now Illinois and Indiana. The Maroa were probably part of the Tamaroa tribe, a branch of the Illinois tribal confederation. Today "Maroa" survives as the name of a village in northern Macon County.

Named for Nathaniel Macon of North Carolina, Macon County was created in 1829 by slicing off the upper third of Shelby County, which, in turn, had been carved from the even larger landmass of Crawford County. Early Illinois counties divided and subdivided like living cells in order to provide more accessible county seats. In the 1820s, early pioneers had to trudge a day or more to obtain a deed or marriage license. In 1830, Decatur became the county seat of Macon County, but there were several small settlements in the area, including one in the Stevens Creek vicinity. In the 1820s, the Lortonniere brothers, also called the Lortons, operated a trading post near Friends Creek. As Decatur grew larger, some farmers chose to live in town and ride out to their farms in a nearby township. Other farms began popping up wherever land was easy to clear and not too swampy. Little settlements emerged in or near present-day Maroa, Warrensburg, Mount Zion, and Macon.

The prairie was a vast, forbidding entity, an open space unlike anything newcomers had encountered, especially those who emigrated from densely-wooded regions of Kentucky and Tennessee. In the dry season, savage prairie fires swept across the grassland, destroying everything in their paths. Marshy and swampy spots bred swarms of malarial mosquitoes. Yet more daunting than these physical discomforts was the acute pain of social isolation. Prairie life was lonely in the extreme, and most of the early settlers preferred the comfort and companionship of villages instead of the unfamiliar vastness of the prairie. A series of old trails and narrow dirt roads connected the isolated settlements with the central town of Decatur.

In 1854, however, everything changed. The railroads arrived that year, and they crossed one another in the city of Decatur, with the Wabash Railroad coming from the west, and the Illinois Central coming from the north. Suddenly new communities were on the map, and towns like Warrensburg and Forsyth were created by the railroad companies. Niantic, the first Macon County town on the Wabash Railroad, was incorporated in 1855, and Maroa, the first stop

on the Illinois Central line, was founded in 1854. Other towns soon followed suit like Oakley (1856), Boody (1870), Blue Mound (1870), Oreana (1872), Mount Zion (1881), Warrensburg (1882), and Long Creek (1882). One of the last villages to be incorporated was Forsyth (1958), now one of the fastest growing areas in the county.

Railroads brought manufactured goods and rare foodstuffs to the outlying areas at the same time that the newly-laid tracks provided access to distant farm and cattle markets. By the start of the Civil War, Macon County farmers were not merely making a living; they were turning a profit. By the 1870s, grain elevators stood along the railroad tracks in towns and villages throughout the county. Much of that grain went to the modern grain mills that were springing up in Decatur. A county hospital was erected. The wealth began to concentrate, and in the 1880s Decatur became a center for banking and agricultural technology. From the very beginning of this boom, Decatur and the surrounding communities enjoyed a powerful symbiotic relationship. Corn produced in the townships became the basis for capital in the city, and that money subsequently financed rural growth. Farm workers often hired on as seasonal laborers at the mills, factories, and foundries of Decatur. Roads gradually improved, and the rural communities arranged themselves like spokes on the hub of a great wheel with Decatur as its center.

Although railroads clearly provided the infrastructure for Macon County, the continued growth and identities of its communities depended on deeply imbedded social institutions, like church and family. Family life was extremely close-knit during the latter part of the 19th century. Family members worked together as an economic unit. They rejoiced in their unique histories and accomplishments, and family reunions or annual family picnics became a marked feature in the social behavior of the county. Families celebrated their persistence with baby pictures, group photographs, and, especially, multigenerational photographs where four or even five generations posed together. During the period from 1895 to 1914, when photography studios appeared in Decatur and Maroa, the majority of images produced were family portraits.

In many respects, early church congregations in the county were extensions of family or clan units. Families of the same faith often traveled westward together, and their destination became the site of a new congregation. Well-established congregations also invited distant family members to pull up stakes and join the group. Church socials and family socials were thus practically indistinguishable. The Methodists established the first church in Macon County in a rough wooden building in 1834. Peter Cartwright, the Methodist circuit rider who once ran against Abraham Lincoln in the 1846 race for congress, preached in Decatur. The Methodists flourished in Macon County, easily surpassing the other denominations by the end of the 19th century, although closely followed by the Christian Church and the Cumberland Presbyterians. After World War II, the Baptists became the most numerous churchgoers in the county. In the 19th century, five church campgrounds existed in Macon County. The Methodists operated a campground at Mount Gilead, while the Cumberland Presbyterians had campgrounds at Mount Zion, Bethlehem, North Fork, and Friends Creek.

Schools were a natural outgrowth of the strong church and family ties. By the 1870s, Decatur public schools were highly efficient and modern, under the leadership of E. A. Gastman, a nationally recognized educator. Even the smallest villages in Macon County built schools, usually one-room affairs. The larger villages, like Warrensburg and Maroa, had large, multi-story buildings and an impressive selection of course offerings. The late Florence White of the Macon County Historical Society has written *Rural Schools of Macon County*, published in 1978, a documentary report on the rural schools. Around 1900, teachers were very close to their students and gave them little souvenir cards on the final day of each school year. Some of those cards, and many photographs of the schools, churches, and families of Macon County, have survived the ravages of time and can still be appreciated today.

One

DECATUR, THE COUNTY SEAT

Founded in 1830 and named after the naval hero Stephen Decatur, Decatur, in its first three decades, was closely linked to the name and career of Abraham Lincoln, who arrived in the town square in the spring of 1830. He and his family remained in Macon County, settling outside present-day Harristown on a bluff overlooking the Sangamon River. Young Lincoln split rails that summer and made his first political speech outside a Decatur tavern. The ensuing winter was one of the worst in Illinois history, and in the spring of 1831, Lincoln left his family to be on his own, landing in New Salem and Springfield. By 1839, Lincoln, a lawyer, was in Decatur on legal business at the Macon County Courthouse working on the Eighth Judicial Circuit Court. Lincoln often stopped in Decatur, staying at the Revere House, his favorite hotel. In 1856, he met with a number of anti-slavery newspaper editors in Decatur and helped to found the Illinois Republican Party. He returned in 1860 for the State Republican convention, and on May 10, 1860, he was nominated for the presidency. After the election, Lincoln visited Decatur for the last time on the morning of February 11, 1861, as his train stopped briefly on its fateful journey to Washington.

Decatur prospered after the Civil War. Small towns sprang up throughout the county, but the city continued to grow exponentially, especially after the A. E. Staley Company began processing corn and soybeans. The growth continued after World War II, as Caterpillar, General Electric, and Borg Warner opened major plants in the city. By the 1970s, however, the pattern began to change as globalization and automation stymied local growth. A regional shopping mall was built in neighboring Forsyth, and Decatur began to lose population as Forsyth, Maroa, and Mount Zion built new streets and subdivisions, while upgrading their school systems. As the 21st century neared, a metro area seemed to be emerging around Decatur, a mega-community that stretched down the middle of the county, from one end to the other.

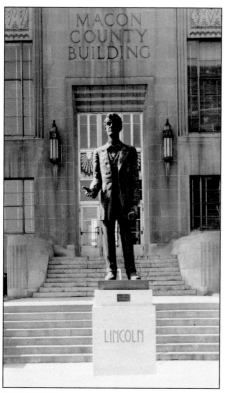

MACON COUNTY BUILDING. This photograph of the bronze statue of Lincoln, standing in front of the Macon County Building while grasping a roll of legal papers in his left hand, was shot by William Pfile for a booklet he prepared in 1948 for the Kiwanis Club of Decatur. The booklet was entitled *Photographic Views.* (Courtesy of Pat Riley.)

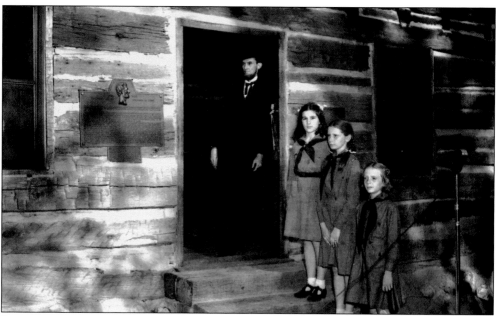

RESTORED LINCOLN COURTHOUSE, 1938. The plaque on the wall just to the left of the door marks the dedication of the restored Lincoln Courthouse. An unidentified Lincoln impersonator and three Girl Scouts are standing on the doorway and steps to honor the occasion. This building is the most tangible connection between Lincoln and the people of Macon County. (Courtesy of Decatur Public Library.)

OLD SETTLERS REUNION RIBBON, 1908. The "Old Settlers" were the original settlers of Macon County. They met from 1883 to 1946 to share their personal stories, and in the process they helped to create the official history of Macon County. Their organization was one of many clubs in Macon County that encouraged socializing and bonding. (Courtesy of Sandy Lynch.)

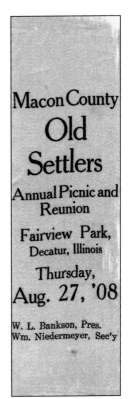

Macon County
Old
Settlers
Annual Picnic and
Reunion
Fairview Park,
Decatur, Illinois
Thursday,
Aug. 27, '08
W. L. Bankson, Pres.
Wm. Niedermeyer, Sec'y

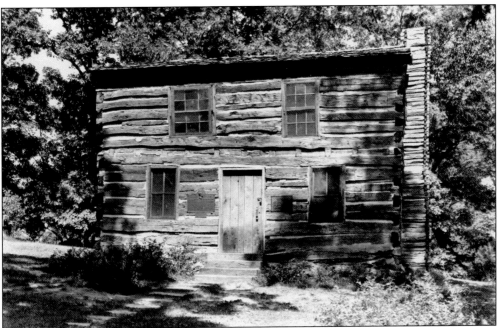

LINCOLN COURTHOUSE, 1948. This photograph shows the original Macon County Courthouse as it appeared in 1948 in Fairview Park, after being restored and relocated many times. It was once moved to a farm outside of Decatur. It is now situated in the Prairie Village on the grounds of the Macon County Historical Society Museum. (Courtesy of Pat Riley.)

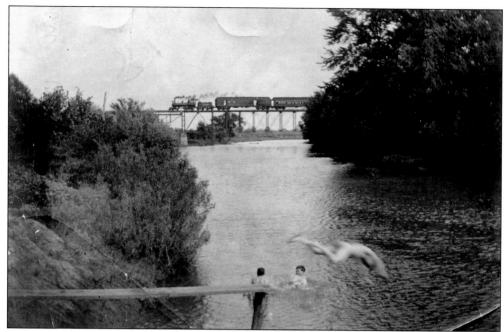

SWIMMING IN THE SANGAMON RIVER. Three young men, in very informal attire, are enjoying a refreshing dip in the Sangamon River on a hot summer day about 1905. The St. Louis Bridge and a coal-fired locomotive with a cowcatcher in front can be seen in the background. (Courtesy of Pat Riley.)

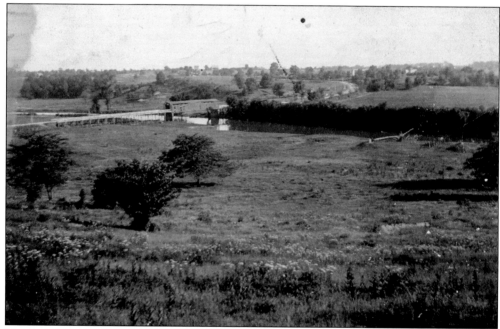

MACON COUNTY BRIDGE. Around 1900, when this photograph was taken, no sharp line of demarcation existed between the "city" and the "country." This meadow with spring flowers is located just north and west of the present U.S. Route 51 bridge. The river was dammed in 1922, and all the green space was eventually used for development. (Courtesy of Pat Riley.)

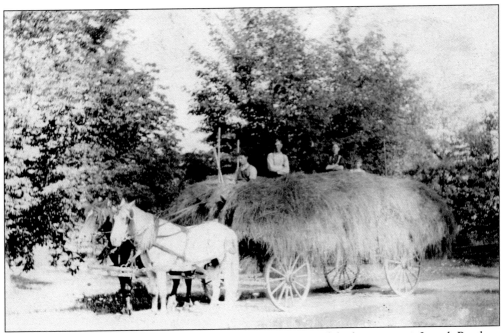

BARTLETT FARM, RURAL DECATUR. The man in the center of the hay wagon is Joseph Bartlett, who owned a farm within the present city limits of Decatur, at a time when agriculture was still the dominant occupation. The hired hands are not identified in this photograph, which was taken in 1908. (Courtesy of Pat Riley.)

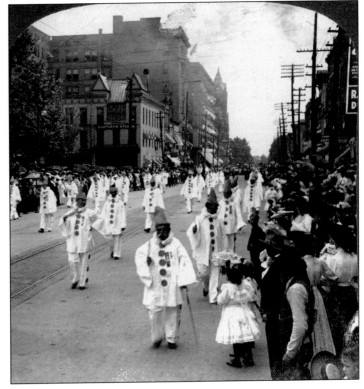

CLOWNS PARADING ON WATER STREET. This photograph of clowns marching down Water Street was taken around 1907 by Decatur's most famous photographer, Charles L. Wasson, while he was working for the International Stereograph Company. Wasson had settled in Decatur after photographing the Second Boer War in South Africa and the San Francisco earthquake in California. (Courtesy of Pat Riley.)

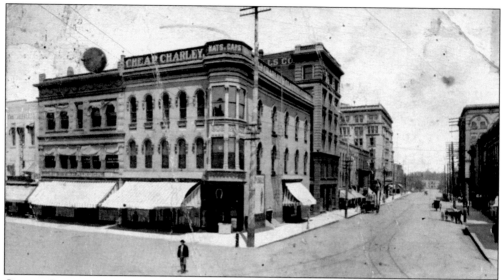

CHEAP CHARLEY'S DEPARTMENT STORE. Cheap Charley's was a landmark in downtown Decatur for many years before it moved to Hickory Point Mall in Forsyth. This photograph shows how the store looked in 1908. After 102 years of continual operation, the business closed in 2006. (Courtesy of Larry Nix.)

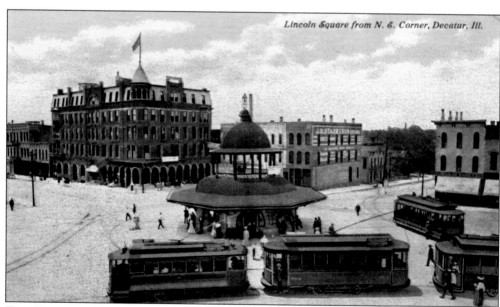

THE TRANSFER HOUSE, 1910. For over 60 years, the Transfer House was the focal point of Decatur life and the hub of the city where countless people in transit had waited patiently for a streetcar or a bus, chatted with neighbors, or just lingered to enjoy the scene. (Courtesy of Pat Riley.)

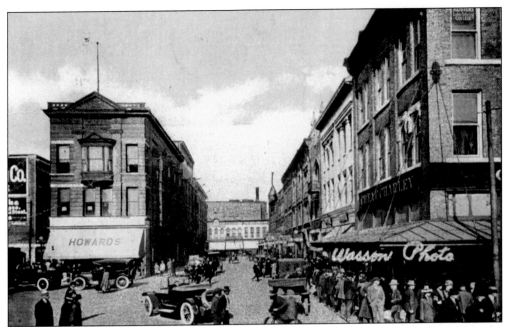

MERCHANT STREET, 1910. This postcard of downtown Merchant Street was made by Charles Wasson, after he had set up his own studio. The building on the right is Cheap Charley's department store. Merchant Street is still an active commercial area, and all the buildings in this picture are still standing today. (Courtesy of Pat Riley.)

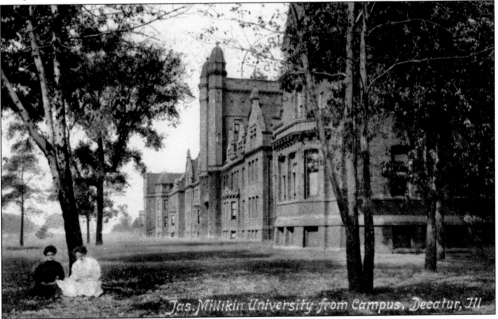

MILLIKIN UNIVERSITY, 1911. This building was constructed between 1901 and 1903 from bricks made in nearby Fairview Park. Students enrolled for the first time in 1903, and the first commencement was held in 1907. Millikin University is the only four-year college in Macon County. Richland Community College, the other institution of higher learning, opened its doors in 1972. (Courtesy of Larry Nix.)

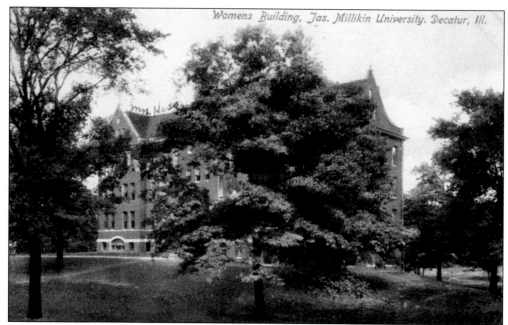

ASTON HALL, 1910. This first residence hall for women on the Millikin University campus had just been built when this postcard was made. There is a legend that Anna Millikin, the wife of founder James Millikin, would come down from her mansion on Main Street to perform a "bed check" on the young women. (Courtesy of Larry Nix.)

MILLIKIN NATIONAL BANK, 1929. James Millikin, the foremost banker in Macon, went into the business shortly after the Civil War, but this magnificent building was not constructed until 1896. This photograph was taken just before the beginning of the Great Depression. The building was demolished in the mid-1970s to make way for a parking lot. (Courtesy of Decatur Public Library.)

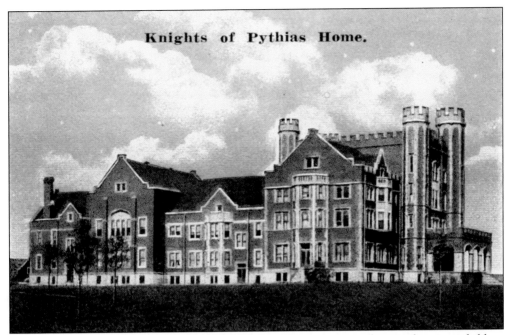

Knights of Pythias Home.

KNIGHTS OF PITHIAS HOME. The Knights of Pithias Home was an orphanage for young children and a rest home for the elderly. It operated for many decades on McKinley Street, just north of the Decatur Memorial Hospital. The building was demolished to make way for the Greater Decatur YMCA, which serves all of Macon County. (Courtesy of David Rush.)

A. E. STALEY MANUFACTURING COMPANY, 1929. A. E. Staley changed the face and fortune of Decatur when he arrived in the early 1900s and began processing cornstarch. In the 1920s he was instrumental in creating Lake Decatur, and he also introduced the soybean to the region. The company is now owned by Tate and Lyle PLC. (Courtesy of Decatur Public Library.)

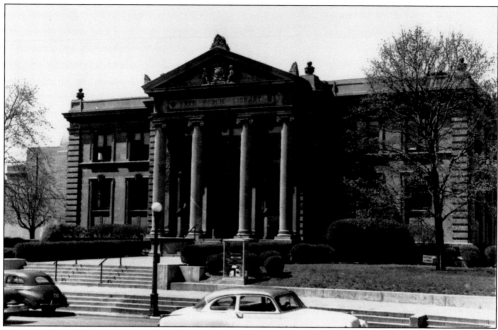

CARNEGIE PUBLIC LIBRARY, 1953. For three-quarters of a century, the Carnegie Library served the Decatur community before it was razed in the mid-1970s. The glass-enclosed structure to the right of the steps is a sidewalk display of new books. The sedan parked in the foreground is a Buick Roadmaster. (Courtesy of Decatur Public Library.)

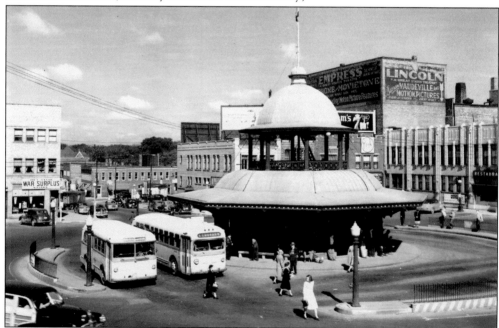

TRANSFER HOUSE, 1948. A woman is crossing the busy roundabout and looking over her shoulder in this 1948 picture of the Transfer House taken by William Pfile. The Transfer House would be gone 15 years later and moved to its present location in Central Park. All the buildings in this photograph remain standing today. (Courtesy of Pat Riley.)

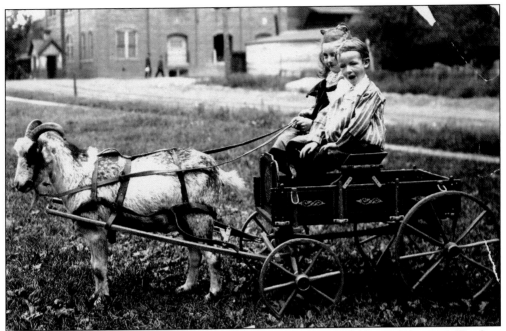

HAROLD AND MABEL LaBRASH. Harold and Mabel were the children of George LaBrash, a machinist at Mueller Manufacturing Company, whose wife's name was Aldena. Harold later worked at Mueller and at Illinois Power. When the picture was taken around 1895, goat carts were very popular. (Courtesy of Decatur Public Library.)

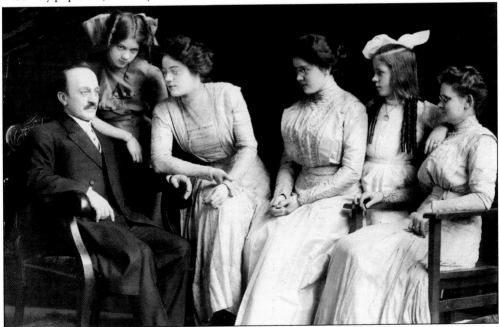

REV. E. H. SHUEY AND FAMILY. The Rev. E. H. Shuey, a United Brethren pastor, is shown here seated, on the left, with his family in a photograph taken about 1915. His wife, Ivah, is seated on the extreme right. In between the couple, from left to right, are daughters Naomi, Pauline, Ulta, and Avice. (Courtesy of Decatur Public Library.)

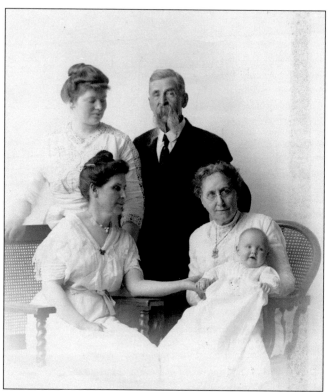

WILLIAM L. SMITH AND FAMILY. William L. Smith was born in 1835 and died in 1917, a few years after this multigenerational portrait was taken in the Vandeventer Studio in Decatur. Smith organized the Goodman Band in 1857, a group that became the municipal band of Decatur. It is still performing today. (Courtesy of Decatur Public Library.)

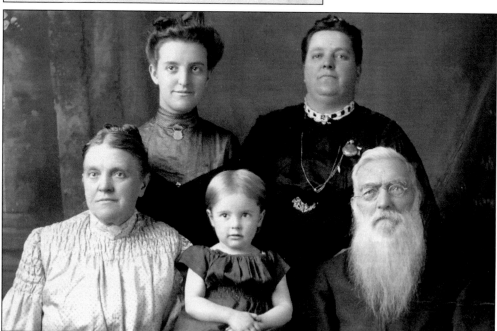

REV. S. F. MILLER AND FAMILY. Seen in this five-generation photograph are, from left to right, (first row) Mrs. J. W. Mulliken, Ruby Stone, and Rev. S. F. Miller; (second row) Mrs. Alvah Stone and Mrs. W. H. Bush. The occasion for this portrait was Miller's 91st birthday. (Courtesy of Decatur Public Library.)

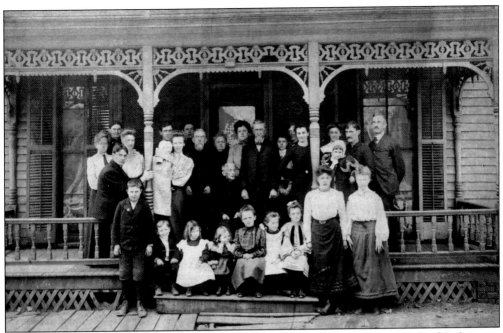

WALMSLEY FAMILY PORTRAIT, 1905. The elderly couple in the very center of this family group is Elizabeth Dudley Walmsley and her husband, Windfield Zahariah Walmsley. The only other people identified are Jenny M. Walmsley and Milton Monroe Bergen, the couple standing on the extreme left of the porch. (Courtesy of Peggy Bergen.)

GARVER FAMILY REUNION, 1906. Family reunions were popular a century ago, and they are still popular today throughout Macon County. These reunions offered an excellent opportunity to reminisce about former times and repeat family stories. Reunions enhanced family solidarity and identity. Members of the Garver family still reside in Decatur. (Courtesy of Pat Riley.)

𝕿𝖍𝖊 19𝖙𝖍 𝕬𝖓𝖓𝖚𝖆𝖑 𝕽𝖊𝖚𝖓𝖎𝖔𝖓 𝖔𝖋 𝖙𝖍𝖊 𝕲𝖆𝖗𝖛𝖊𝖗 𝕱𝖆𝖒𝖎𝖑𝖞

WILL BE HELD AT

FAIRVIEW PARK, DECATUR, ILLINOIS

THURSDAY, AUGUST 30, 1906

A program consisting of music, addresses and literary selections will be rendered during the day. Garvers, Garver relatives and their friends are cordially invited to bring their dinners and enjoy an all day picnic.

DAVID H. GARVER, President
DECATUR, ILL.

MYRTA M. GARVER, Secretary
DECATUR, ILL.

INVITATION FOR GARVER REUNION. Most families did not print formal invitations for reunions, but the Garver Family Reunion of 1906 was a gala event, with music, speeches, and literary readings. Like many other reunions it was held in Fairview Park, a popular place for such gatherings. (Courtesy of Pat Riley.)

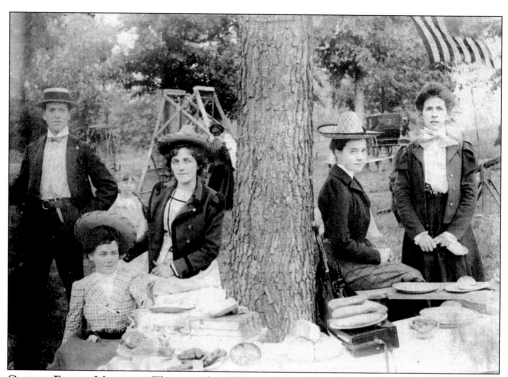

GARVER FAMILY MEMBERS. These unidentified members of the Garver clan seem to be enjoying the picnic. An American flag is flying above them, and the ladies sport their western-style hats. The young gentleman on the left is wearing a boater hat and has inserted a table knife like a dagger under his belt. (Courtesy of Pat Riley.)

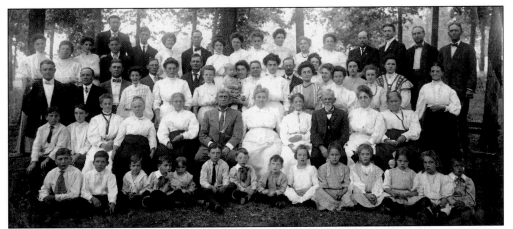

DAWSON FAMILY REUNION. Roy Dawson, in bow tie and dark suit, is seated in the second row, third from the right. The other members of the family are not identified. Roy Dawson became one of the partners in the Dawson and Wikoff Funeral Home. His extended family was rather large, as shown in this portrait taken about 1910. (Courtesy of Decatur Public Library.)

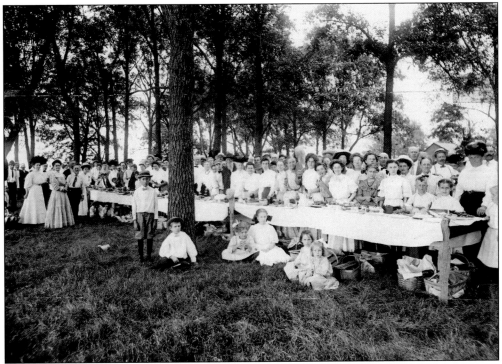

BACHRACH FAMILY PICNIC, 1908. A family picnic in this era could take on a formal air, as shown by the women's hats, men's ties, and even the children's dressy outfits. Bow ties for boys and hair ribbons for girls were the order of the day. The abundant table was probably set up in Fairview Park. (Courtesy of Decatur Public Library.)

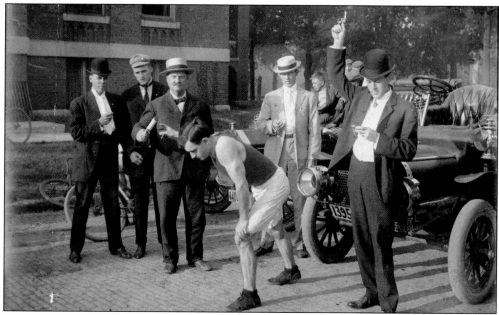

YMCA Race. Sports and athletic contests were a key part of the social scene in Macon County, and the YMCA provided a venue for all sorts of games and contests, open to residents of the entire county. The runner is probably racing against the clock in this photograph taken about 1910. The spectators are nattily attired, and the automobiles are brightly polished. (Courtesy of Decatur Public Library.)

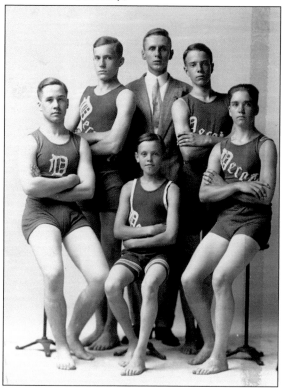

Junior Swimming Team, 1911. Swimming tournaments and other sporting events provided an opportunity for social interaction, both for the participants and the spectators. The members of the 1911 YMCA Junior Swimming Team are, from left to right, (first row) Everett Boose (captain), Ray Wright, and Scott McNulta; (second row) Everett Brown, Loren Hodge (manager), and Roy Baker. (Courtesy of Decatur Public Library.)

YWCA WOMEN'S BASKETBALL TEAM, 1916. The YWCA offered one of the few places for women to play basketball competitively in 1916. Note the uniforms in the style of a man's sailor suit, a popular look in the World War I era. (Courtesy of Decatur Public Library.)

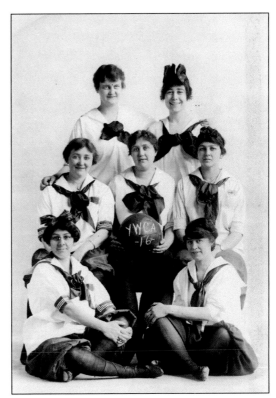

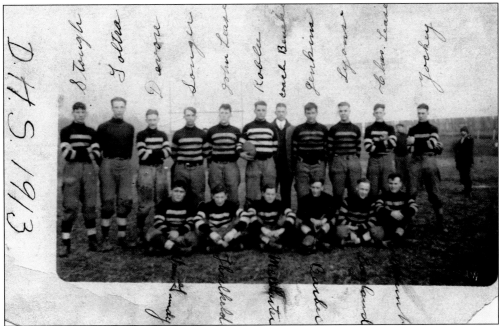

DECATUR HIGH SCHOOL FOOTBALL TEAM, 1913. The team members were identified only by their last names. From left to right are (first row) Van Gundy, Threlkeld, McWherter, Barber, England, and Mount; (second row) Stough, Goltra, Devore, Songer, John Lease, Roblee, Beuche (coach), Jenkins, Lyons, Charles Lease, and Yockey. (Courtesy of Decatur Public Library.)

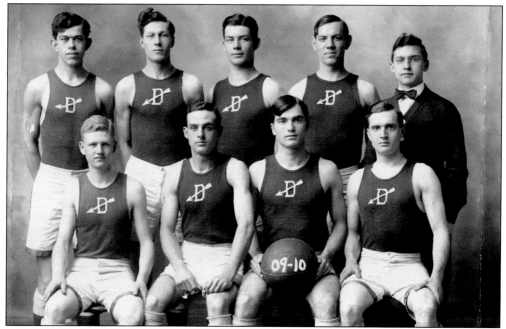

YMCA BASKETBALL TEAM, 1910. The 1910 champions are, from left to right, (first row) Elmer Glan, Terry Mahan, Robert Thrift (captain), and Ralph Tenney; (second row) Bert Chance, Carl Wise, Raymond Judy, Will Ott, and W. H. Duerr (coach). The distinctive logo of a *D* pierced by an arrow was not used again. (Courtesy of Decatur Public Library.)

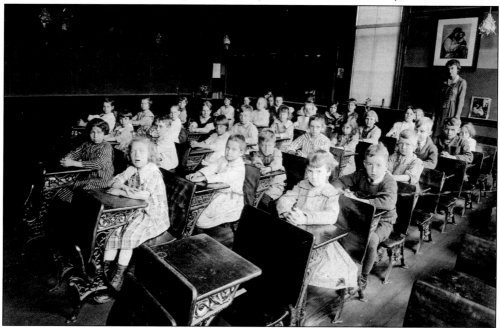

DECATUR SCHOOL CHILDREN, 1919. This unidentified class was photographed right after World War I. The students and teacher are dressed up for the occasion. Note the picture of the Madonna and Child on the rear wall behind the teacher. At that time religious art was permitted in public schools. (Courtesy of Ann Adkesson.)

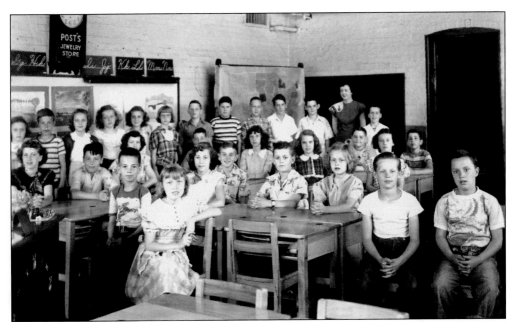

ULLRICH SCHOOL, 1949. These unidentified fifth graders at Ullrich School were arranged by the photographer in an interesting way to break up the grid of the classroom. A clock from Post Jewelry Store is hanging on the wall, penmanship samples are tacked above the bulletin boards, and the little boy in the front, on the lower left side, is proudly wearing his Roy Rogers polo shirt. (Courtesy of Decatur Public Library.)

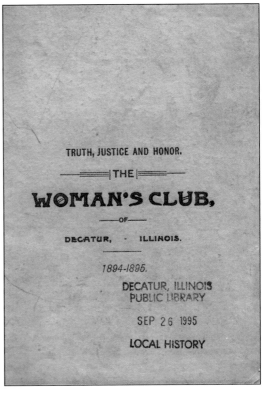

WOMAN'S CLUB OF DECATUR, 1894. The Woman's Club of Decatur was organized in 1887, and it existed for over half a century. There were over 230 members when this Annual Report was printed in 1894. This club was one of several active organizations in the county, including the Knights Templar, the Independent Order of Odd Fellows, and the Masons. (Courtesy of Decatur Public Library.)

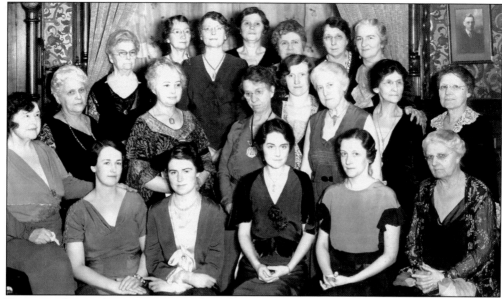

DECATUR STUDY CLASS, 1933. Seen here from left to right are (first row) Mrs. F. L. Evans, Mrs. E. L. Simmons, Eleanor Wood, Helen Gorham, Marian Wait, and Mrs. E. L. Pegram; (second row) Mrs. Frank Curtis, Mrs. Robert Mueller, Gussie Gorin, Honore Owen, Jessie Lockett, Mrs. C. R. Murphy, and Lillian Chadsey; (third row) Anna Pegram, Mary Crea, Mrs. C. M. Wood, Mrs. C. M. Jack, Mrs Guy Parke, Mrs. E. A. West, and Mrs. Adolph Mueller. (Courtesy of Decatur Public Library.)

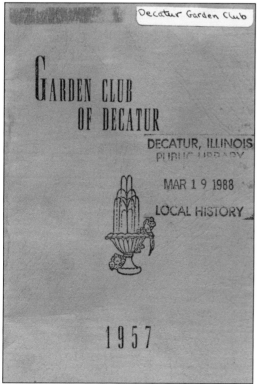

GARDEN CLUB OF DECATUR, 1957. The Garden Club of Decatur was another busy and influential group when this booklet was printed in 1957. The Garden Club Creed included the pledge to "share garden blooms with the afflicted and my knowledge and experience with other gardeners." (Courtesy of Decatur Public Library.)

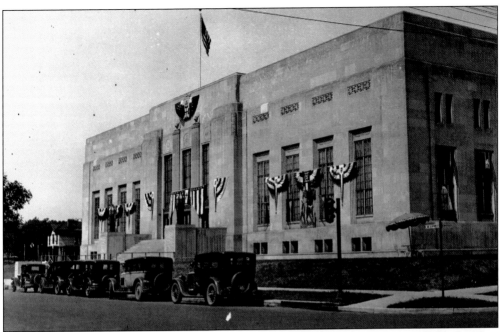

MASONIC TEMPLE, 1929. This picture was made shortly after the opening of the building in January 1929. The Masonic temple was judged to be the most beautiful public building in downstate Illinois. The Masons were the most visible and ancient of the fraternal organizations in Macon County. (Courtesy of Decatur Public Library.)

St. Paul's Methodist Episcopal Church
1600 East North Street

Parsonage St. Paul's M. E. Church
Rev. J. C. Brown, Pastor
922 North First Street Decatur, Illinois

ST. PAUL'S CHURCH AND PARSONAGE. St. Paul Methodist Episcopal Church and Parsonage are shown here as they looked about 1915, when J. C. Brown was pastor. Parsonages at the time were usually simple and spartan, consisting of a small frame house or cottage. (Courtesy of Decatur Public Library.)

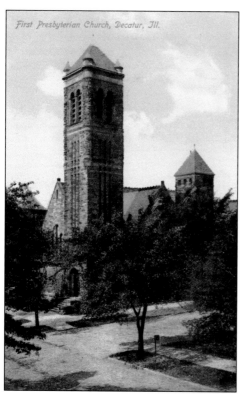

First Presbyterian Church, Decatur, Ill.

FIRST PRESBYTERIAN CHURCH. Constructed of Indiana limestone, the First Presbyterian Church has stood proudly at the corner of Church and Prairie Streets in Downtown Decatur for over a century. It is a distinctive landmark, with its pointed gables and elegant bell towers. This photograph was taken about 1910. (Courtesy of Pat Riley.)

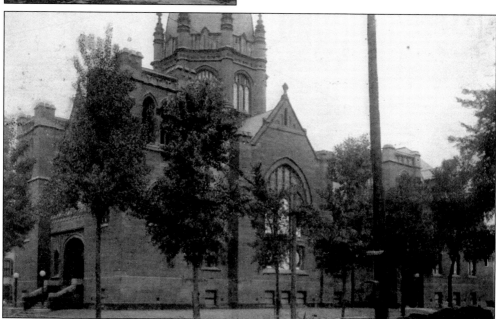

FIRST METHODIST EPISCOPAL CHURCH, 1909. The very first house of worship in Macon County was a Methodist church, which was actually a one-room wooden building erected in 1834. The Methodists were the largest denomination in Macon County until after World War II when the Baptists began to take the lead. The church shown in this picture is still standing and it has recently been renovated. (Courtesy of Decatur Public Library.)

ST. JAMES CATHOLIC CHURCH, 1920. St. James Catholic Church once stood next to St. Mary's Hospital before the hospital moved to Lake Shore Drive. St. James Parish once operated a thriving elementary school, but it closed in 2006. The church is still in use, however. (Courtesy of Decatur Pubic Library.)

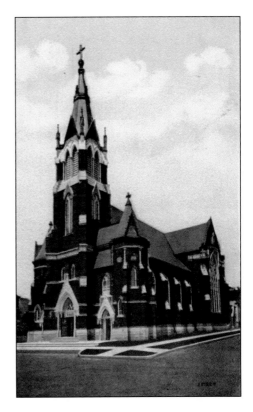

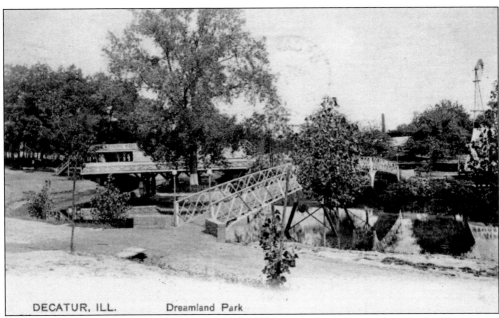

DECATUR, ILL. Dreamland Park

DREAMLAND PARK. Now part of the grounds of Fairview Park, Dreamland Park offered rides and amusements during the pre–World War I era. It was very popular with residents of the entire county, and the lake in this picture is still part of Fairview Park, known locally as the Duck Pond. (Courtesy of Decatur Public Library.)

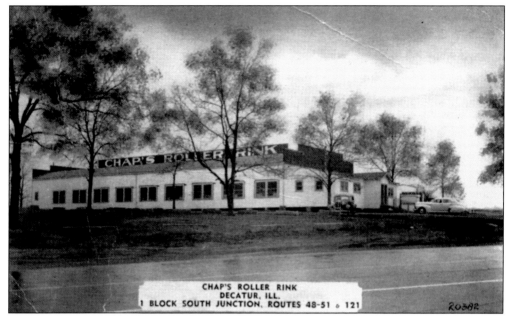

CHAP'S ROLLER RINK, 1948. Chap's Roller Rink and amusement park, a landmark on the far north side of Decatur, was the busiest and most popular amusement park in Macon County, fondly remembered by the baby boomer generation and many others. Besides the skating rink, Chaps offered its eager customers a Ferris wheel and various carnival rides. (Courtesy of Pat Riley.)

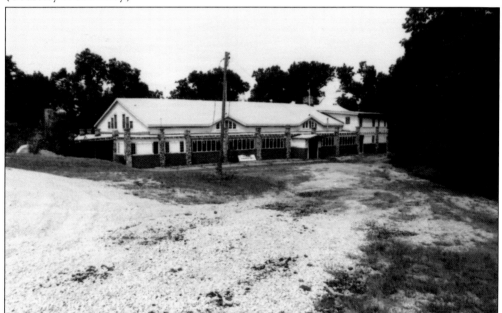

DANCELAND. Located on the south side of Decatur, Danceland was another popular site for skating, dancing, and various pastimes. Many people from throughout the county visited the place on weekends. Originally designed as a meeting hall for the Elks, Danceland was remodeled and flourished from 1940 to 1965. The sign in front reads "Country Opry." (Courtesy of Doug Imboden.)

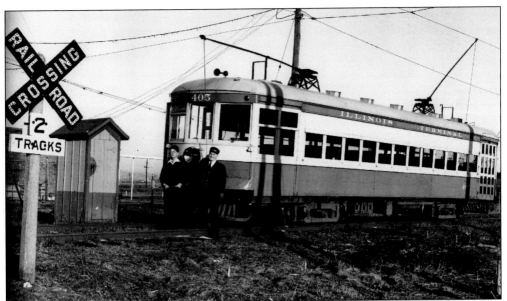

ILLINOIS TERMINAL RAILROAD, 1953. The Illinois Terminal Railroad or interurban was originally called the Illinois Traction System or ITS. This electric train connected Danville and Champaign in 1903, but it eventually reached Bloomington, Decatur, Springfield, and St. Louis. It became the trolley for Macon County, often stopping in the middle of a field. Passengers occasionally rode with live chickens, tools, or other personal items. (Courtesy of Decatur Public Library.)

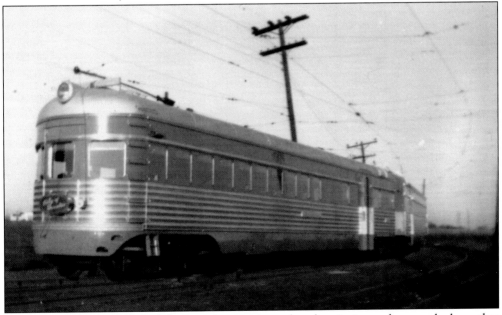

CITY OF DECATUR. After the steam locomotives, the electric interurban marked another revolution, especially for personal transportation and mail. A person living in Maroa, say, in 1908, could mail a penny postcard in the morning and have it delivered via the interurban to Decatur or Niantic the same afternoon. The *City of Decatur* was the most luxurious train on the line. (Courtesy of Decatur Public Library.)

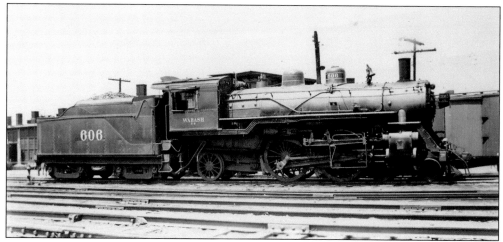

WABASH LOCOMOTIVE 606. This working train was photographed on Sunday, May 26, 1935. Decatur was always considered a "Wabash Town" because the Wabash Railroad had a major repair shop and administrative office in the city. Famous trains like the *Bluebird* and the *Wabash Cannonball* came through town regularly. (Courtesy of Pat Riley.)

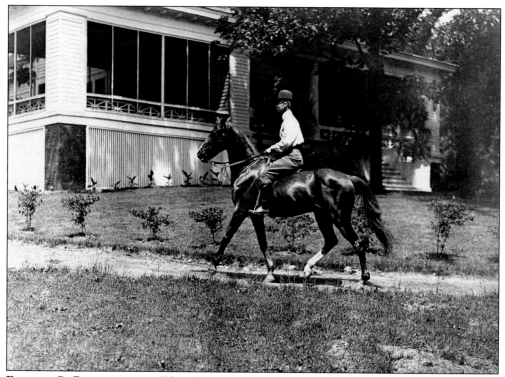

EDWARD G. POWERS, 1908. Edward G. Powers, a member of the influential Powers family, is seen riding his horse in June 1908, the same year the Model T appeared on the scene. Powers lived to the age of 89, dying in 1950. This photograph was discovered by Jack French of Cerro Gordo in 1954, while looking through negatives belonging to J. K. Stafford. (Courtesy of Decatur Public Library.)

Two

THE WESTERN TOWNS AND WARRENSBURG

A natural landform, a long ridge or mound covered with prairie grass, provided the name for one township and for one town in the southwest corner of Macon County: Blue Mound. The town of Blue Mound is in Pleasant View Township, and the village of Boody is located in Blue Mound Township. William Warnick, the very first sheriff of Macon County and a neighbor and friend of Abraham Lincoln, was the first settler in Blue Mound Township. Boody attracted a number of German immigrants, like George Nolle, or the sons of immigrants, like the Bailey brothers (Harry, John, and Charles). Other immigrants in the area came from Ireland, like Thomas Gabriel of Blue Mound who hailed from County Cork. By 1871, Blue Mound had a schoolhouse and a hotel.

Niantic looks like a tab sticking out from the western edge of Macon County. Niantic was erroneously considered too swampy for agriculture, so Sangamon County sold Niantic Township to Macon County at a bargain price. Today it is highly productive farm land. The Wabash Railroad enters Macon County in Section Nine of Niantic Township. Niantic was laid out in 1852 and incorporated in 1855. The first house was built by Jesse Lockhart. In the Civil War era, Niantic had a Christian church, a gristmill, a blacksmith shop, and a bank. Among the successful farmers around 1900 were Daniel and Thomas Moore, who had emigrated from Ireland in 1863 and 1874 respectively.

Harristown derives its name from Maj. Thomas Harris of Mexican War fame. Thomas Lincoln and his family, including Abraham, arrived in the Harristown Township in 1830, and Thomas settled briefly in Section 28 in 1831. Daniel and Lewis Stookey were two of the early farmers who prospered in Harristown.

Warrensburg was the most important town outside of Decatur and Maroa. It was named after J. K. Warren and situated on the Peoria line of the Illinois Central Railroad. In 1900, it had an opera house, grain elevator, schools, churches, and many thriving businesses.

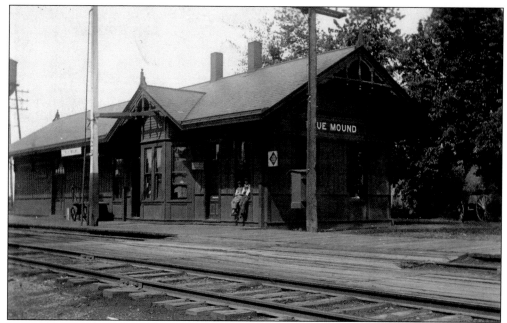

BLUE MOUND DEPOT, 1916. This Wabash Railroad station offered telegraph service, as did most of the depots at that time. The year after this picture was taken, the United States entered World War I, but the two boys are enjoying a sleepy day, waiting for the next train to arrive in Blue Mound. (Courtesy of Pat Riley.)

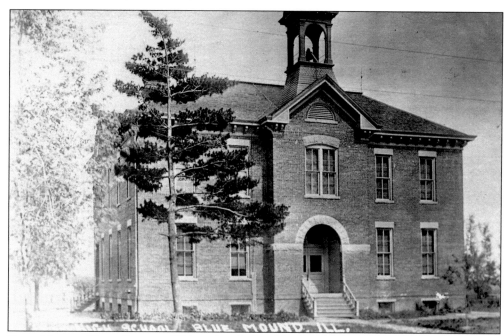

BLUE MOUND HIGH SCHOOL. This style of school building, basically a two-story box with a well-defined cupola and vestibule, was fairly typical of the better country schools around 1910. Poorer districts relied on simpler wooden structures. Blue Mound was an affluent community. (Courtesy of Pat Riley.)

METHODIST EPISCOPAL CHURCH. This photograph shows the Methodist Episcopal Church and its matching activities building on a sunny day in 1948. The Methodist Episcopal Church eventually became the United Methodist Church. Methodists outnumbered all other denominations in Macon County until the 1950s. (Courtesy of Pat Riley.)

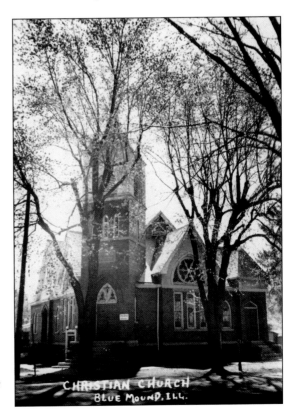

BLUE MOUND CHRISTIAN CHURCH. The Christian Church is one of the best represented denominations in Macon County. Many of the Christian Church buildings featured extensive use of stained glass windows, as seen in this 1948 photograph of the Blue Mound Christian Church. (Courtesy of Pat Riley.)

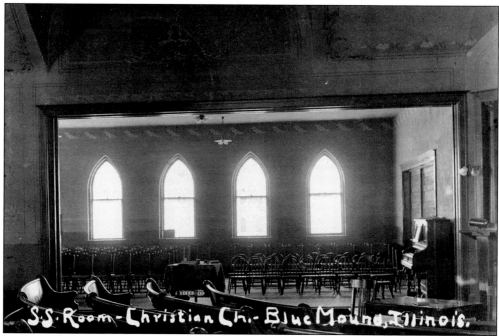

SUNDAY SCHOOL ROOM, 1912. This early photograph of the Blue Mound Christian Church Sunday School Room was taken in 1912. Sunday school classes and youth ministries were a very important part of social and community life in Macon County. (Courtesy of Pat Riley.)

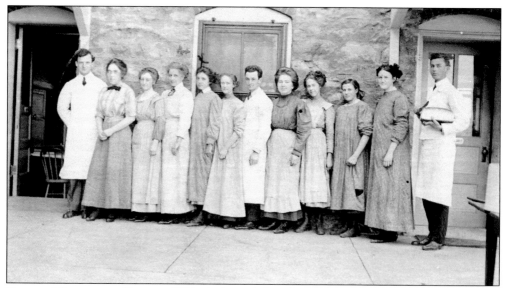

BAKERY WORKERS IN BOODY, 1911. A dozen bakers line up outside a bakery in Boody, near Blue Mound, to pose for this group photograph. Note the gentleman on the extreme right with a finished loaf, holding a knife as if to slice the bread. The women are smiling and appear to be a very congenial group. (Courtesy Pat Riley.)

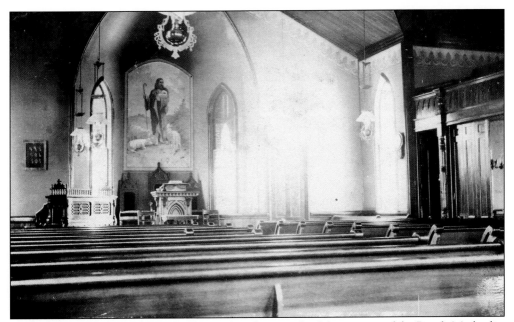

METHODIST EPISCOPAL CHURCH, 1910. This photograph of the interior of the Boody Methodist Episcopal Church shows a painting of Christ as the Good Shepherd. It dominates the scene. On the left side is a framed bulletin board with the hymns for the day, numbers 495, 506, and 509. (Courtesy of Pat Riley.)

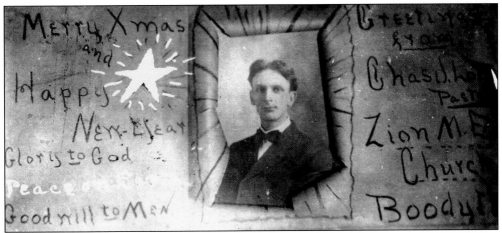

HOMEMADE CHRISTMAS CARD, 1910. Pastor Charles J. Lotz personally made this Christmas card for his congregation at the Zion Methodist Episcopal Church of Boody during the Christmas season of 1910. Many Christmas artifacts, including cards and decorations, have survived over the past century in Macon County. (Courtesy of Pat Riley.)

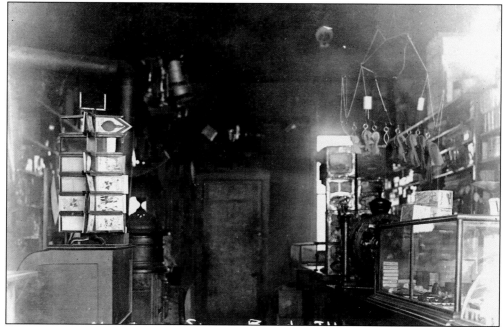

NIENTKER'S STORE, 1912. This country store in Boody was typical of other establishments in the county. Nientker's Store offered postcards and greeting cards from the rack shown on the left. There were many German immigrants in the area who probably patronized Nientker's Store. (Courtesy of Pat Riley.)

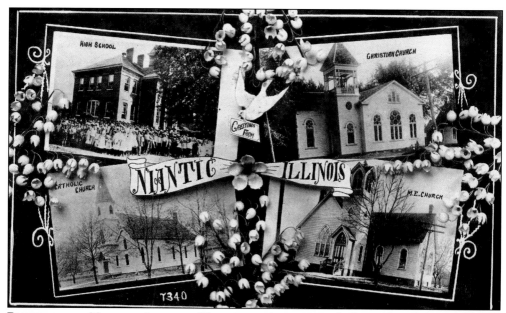

PANORAMA OF NIANTIC, ILLINOIS. These inset pictures are, clockwise from left to right, the High School, the Christian church, the Methodist Episcopal church, and the Catholic church. Many small towns produced this kind of card to promote themselves and to express their civic pride. Also there were few published images of the towns, so a ready market existed. (Courtesy of Pat Riley.)

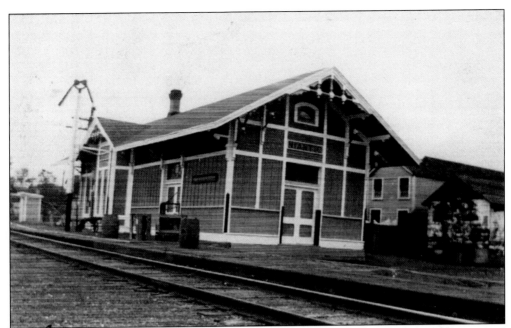

WABASH DEPOT, NIANTIC. This architecturally interesting depot, with elaborate eaves and exposed beams, was the first Macon County stop for Wabash Railroad traffic arriving from the west. The Wabash Depot is located in Section Nine of Niantic Township. This photograph was taken about 1910. (Courtesy of Pat Riley.)

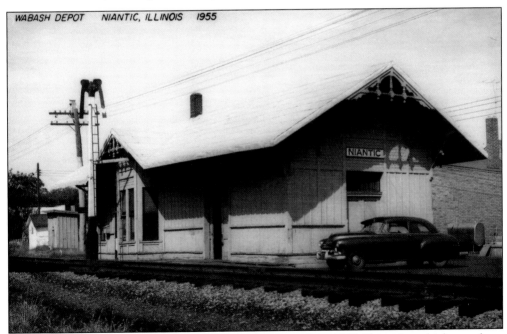

WABASH DEPOT, 1955. The automobile in the foreground is a 1949 Chevrolet, which was about six years old when the photograph was made in 1955. This station had become something of a local landmark, having served the locals for several generations. It stood the test of time surprising well. (Courtesy of Pat Riley.)

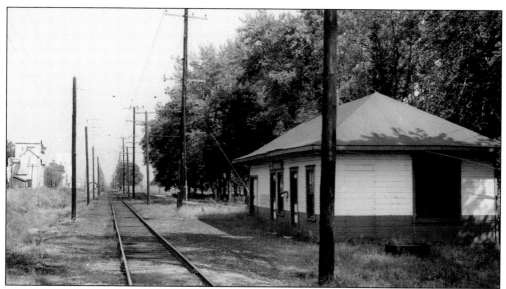

ILLINOIS TRACTION RAILROAD DEPOT, 1955. Niantic was fortunate to be served by the Illinois Traction Railroad or interurban, as it was popularly known. The state capital of Springfield was only a few minutes away from Niantic, via this efficient and clean electric railway, which ran frequently, like a trolley. (Courtesy of Pat Riley.)

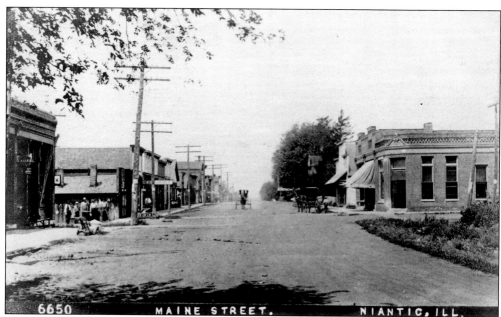

MAIN STREET, NIANTIC. This postcard was postmarked in 1910, but the photograph is older, dating to 1905 or a little earlier. Significantly there are no cars in the picture, and they did not appear in Macon County until about 1905. Note the misspelling of Main Street as "Maine." A restaurant and meat market are visible on the left side of the street. (Courtesy of Pat Riley.)

NIANTIC HIGH SCHOOL, 1907. This impressive public school building was photographed by the International Stereograph Company, which, at the time, was being run by distinguished photographer Charles L. Wasson. The building was well appointed, with a bell tower, flagstaff, foyer, and full basement. (Courtesy of Larry Nix.)

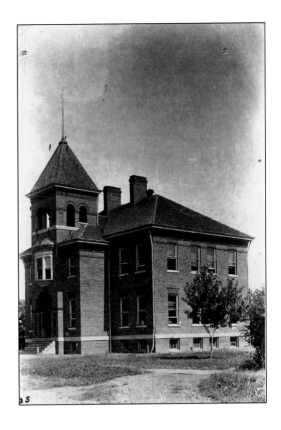

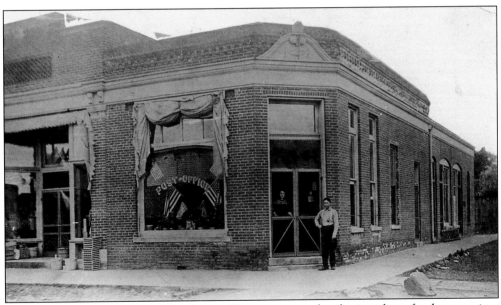

NIANTIC POST OFFICE, 1909. Rural post offices were natural gathering places for the gregarious citizens of small towns and villages. Postmasters were privy to all the local gossip. There is a general store immediately to the left of the post office. The man standing on the sidewalk is not identified. (Courtesy of Larry Nix.)

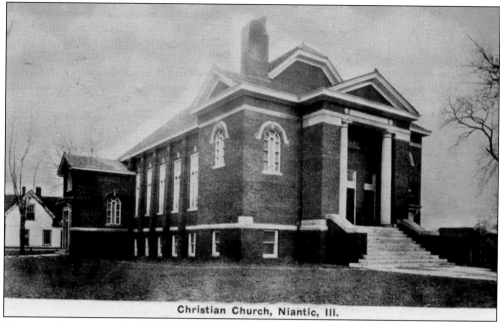

Christian Church, Niantic, Ill.

NIANTIC CHRISTIAN CHURCH. This impressive church with Doric columns rests on a high foundation, enclosing a full basement. The photograph was taken about 1915. The cottage in the back of the church, on the lower left side of the picture, may have been the parsonage. (Courtesy of Pat Riley.)

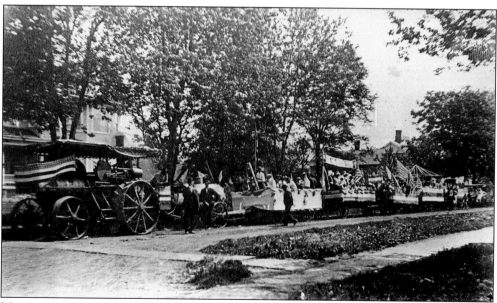

METHODIST EPISCOPAL SUNDAY SCHOOL PARADE. A wide-angle camera caught the Methodist Episcopal Church Sunday school class on parade, about 1905. The floats are being drawn by a steam-powered tractor, and the banner on the second float reads, "M. E. Sunday School." (Courtesy of Larry Nix.)

FARMERS' GRAIN ELEVATOR, NIANTIC.
Most rural grain elevators are utilitarian in design with no fancy frills, but this elevator in Niantic has a unique architectural design. The crenellations or notches at the tops of the elevator towers lend the whole assemblage the look of a medieval castle. This photograph was taken about 1910. (Courtesy of Larry Nix.)

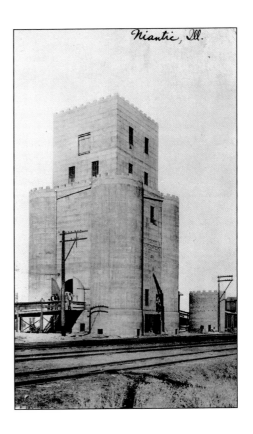

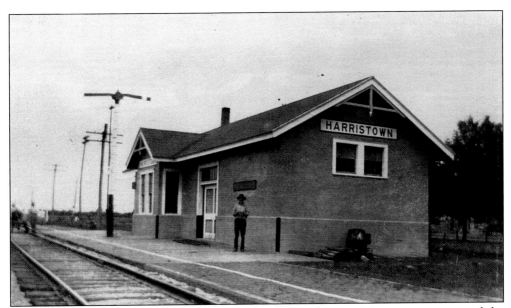

WABASH DEPOT, HARRISTOWN. This neat and well-kept depot in Harristown represented the second stop on the Wabash Railroad line as the trains came in from Niantic and Springfield to the west. The photograph was probably made about 1915. (Courtesy of Pat Riley.)

JOHN H. PARK. One of Harristown's early distinguished residents, John H. Park was a traveling salesman, a notary public, and an insurance agent. He spent his childhood in Salem, where he was a boyhood friend of the famous orator William Jennings Bryan. (Courtesy of Decatur Public Library.)

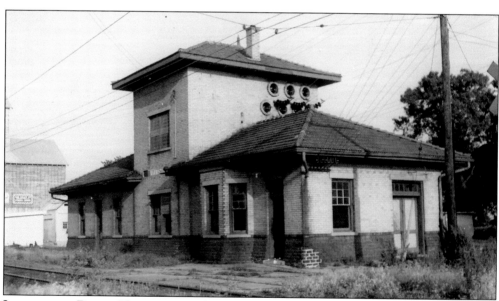

INTERURBAN DEPOT, HARRISTOWN. As an electric railway, the interurban provided quiet and dependable service to the county seat of Decatur, which was only a few minutes away. Doctor visits, shopping trips, and family visits were very easily accomplished. This photograph was taken on June 7, 1953. (Courtesy of Pat Riley.)

HARRISTOWN CHRISTIAN CHURCH.
From March 12 to March 15, 1961,
the Harristown Christian Church
staged an elaborate celebration to
honor its centennial. For nearly a
century and a half, this church has
been a cornerstone of the Harristown
community. (Courtesy of Decatur
Public Library.)

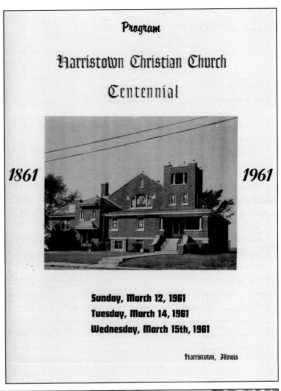

Program

Harristown Christian Church

Centennial

1861 1961

Sunday, March 12, 1961
Tuesday, March 14, 1961
Wednesday, March 15th, 1961

Harristown, Illinois

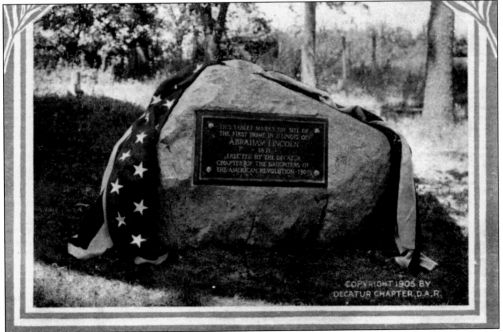

LINCOLN HOME MONUMENT. Erected by the Daughters of the American Revolution (DAR) in
1905, this bronze tablet set in a large boulder marks the site of Abraham Lincoln's home when
he first settled in Illinois in the spring of 1830. The site is on a bluff overlooking the Sangamon
River west of Harristown. (Courtesy of Pat Riley.)

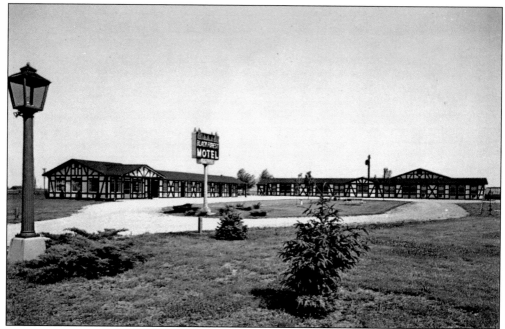

THE BLACK FOREST MOTEL, HARRISTOWN. This wayside inn has undergone several renovations. It is located on old U.S. Route 36, just west of Harristown and a few miles from the Lincoln Home site on the banks of the Sangamon River. (Courtesy of Pat Riley.)

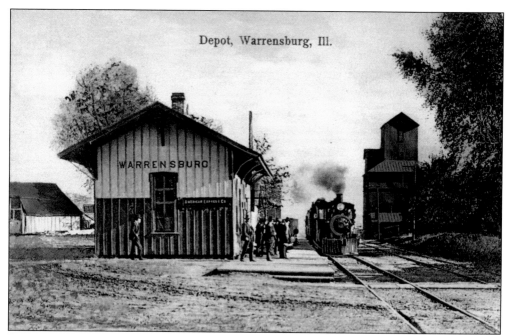

ILLINOIS CENTRAL DEPOT, WARRENSBURG. This depot was probably the most recognizable building in the growing town of Warrensburg since virtually everyone had business there, sooner or later. This postcard image was created by C. A. Dresbach, a Warrensburg resident who went into the postcard business about 1910. (Courtesy of Barclay Public Library.)

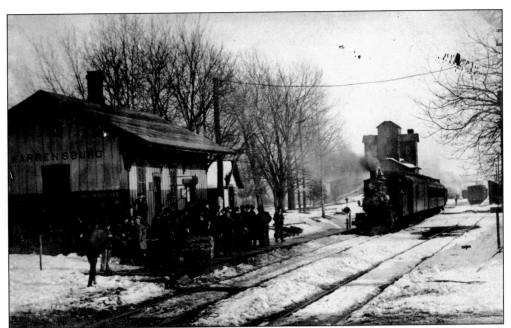

ILLINOIS CENTRAL DEPOT, 1907. On a bright, snowy day in the winter of 1907, a smiling and excited crowd eagerly welcomes the arrival of Illinois Central locomotive No. 1214 as it arrives from Peoria and points to the north. (Courtesy of Pat Riley.)

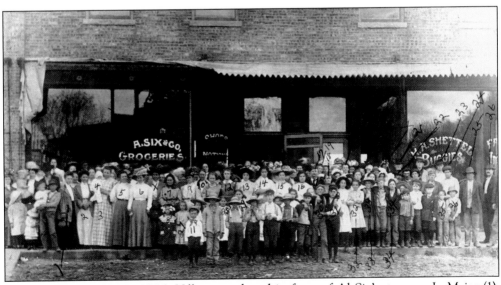

VILLAGE PHOTOGRAPH, 1906. Villagers gathered in front of Al Six's store are L. Major (1), A. Buckley (2), M. Slovaker (3), D. Slovaker (4), Z. Haywood (5), unidentified (6), J. Oakes (7), A. Brown (8), M. Batchelder (9), W. Schroeder (10), A. Major (11), R. Buckley (12), E. Wharton (13), J. Mixell (14), F. Taggert (15), K. Wharton (16), A. Six (17), Y. Bennet (18), C. Ritchie (19), Mrs. A. Six (20), D. Schroll (21), ? Hensley (22), E. Buckley (23), B. Disney (24), L. Boyer (25), T. Hoaglin (26), M. Smithy (27), ? Ennis (28), ? Ennis (29), R. Berman (30), H. Manion (31), B. Baumgardner (32), C. Schroeder (33), E. Boyer (34), P. Dickerson (35), and E. Major (36). (Courtesy of Barclay Public Library.)

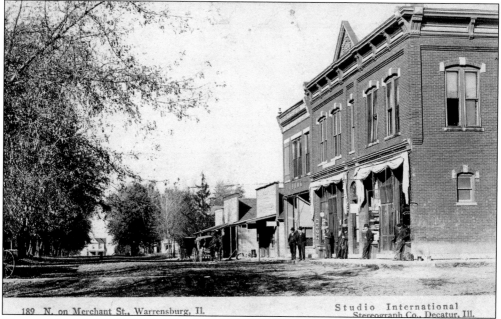

189 N. on Merchant St., Warrensburg, Il.

Studio International
Stereograph Co., Decatur, Ill.

NORTH MERCHANT STREET. This photograph was taken about 1910 by the International Stereograph Company of Decatur, which was managed by Charles L. Wasson. The men standing on the sidewalk are probably local businessmen. The carving on the pediment of the brick building reads "Ritchie Block." At the time, the Ritchie family was very influential in Warrensburg. (Courtesy of Barclay Public Library.)

SOUTH MERCHANT STREET. The street is muddy and clearly shows the wheel ruts of buggies and wagons. On the left stands a little brick building that served as the village hall. The railroad tracks belong to the Illinois Central Railroad. The photograph was taken by Charles L. Wasson's company. (Courtesy of Pat Riley.)

50

FERRY'S BAKERY BREAD COUPON. Even in 1900-era Warrensburg, a coupon for a free loaf of bread was a powerful marketing tool. Bakeries only operated in prosperous communities where families were too busy to bake their own bread, as they had done in the past. (Courtesy of Sandy Lynch.)

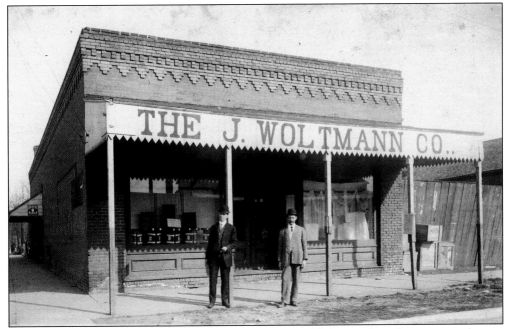

THE J. WOLTMANN COMPANY. The Woltmann store sold dry goods and sewing supplies, or "notions," as they were called. When this photograph was taken, around 1905, the featured item in the window was percale cloth, which was sold by the bolt. (Courtesy of Pat Riley.)

CHRISTMAS ENTERTAINMENT, 1896. At this Christmas entertainment in 1896, Minnie Ritchie played the piano for the program, which featured songs by the Newsboys and the Newsgirls. The event took place at the Warrensburg Opera House. The only other towns with opera houses were Decatur and Maroa. (Courtesy of Ann Adkesson.)

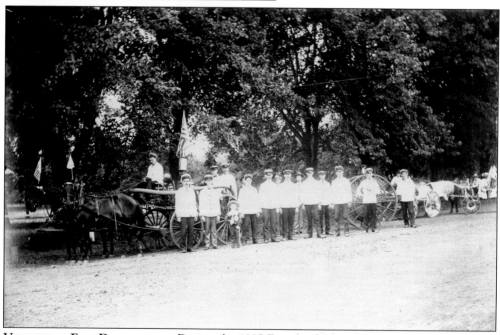

VOLUNTEER FIRE DEPARTMENT. During the 1905 Fourth of July celebration, the Warrensburg Volunteer Fire Department, with businessman H. H. Shettel at the reins, paraded through town. There was also a Baby Show with prizes for the fattest, most intelligent, and prettiest babies. The Warrensburg *Times Print* called it a "bully" time. (Courtesy of Barclay Public Library.)

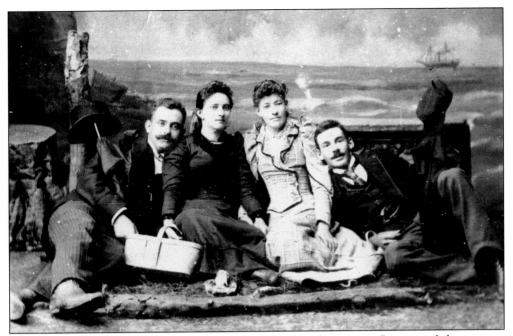

Two Warrensburg Couples. These couples had taken the train to Peoria, and they pose at the Sunbeam Galley on South Adams Street for this playful photograph. They are, from left to right, ? Johnson, Inez Taggert, and Mrs. and Mr. Batchelder. The clothing is late Victorian or early Edwardian in style. (Courtesy of Barclay Public Library.)

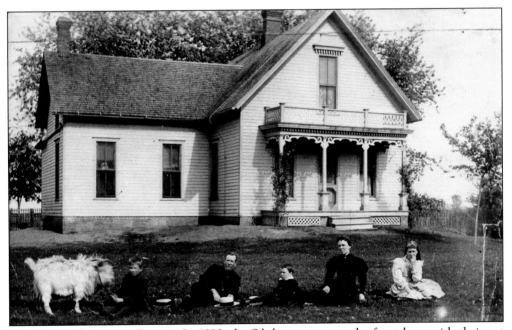

The Josiah Sibthorp Family. In 1898, the Sibthorps pose on the front lawn with their pet goat. They are, from left to right, Will, Josiah, Fred, Julia, and Lillie. The Sibthorps were charter members of the Methodist Church of Warrensburg. (Courtesy of Sandy Lynch.)

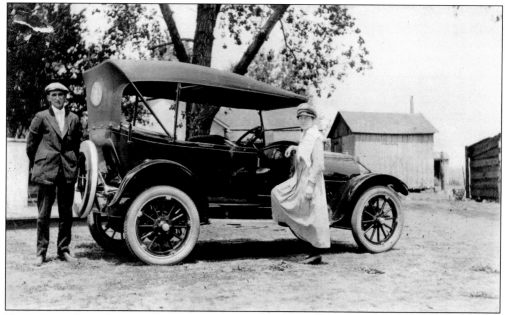

HARVE AND LOIS COUCH. On a brilliantly sunny day in 1917, Harve Couch and his wife Lois, of rural Warrensburg, are proudly showing off their new touring car as they model the latest in fashion. The buildings in the background are part of their farm. (Courtesy of Sandy Lynch.)

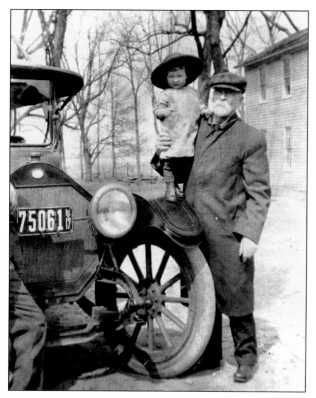

ALONZO DISBROW, 1917. Alonzo Disbrow is shown here posing with William, his grandson, next to a Pratt touring car in rural Warrensburg. It was still common at this time to dress little boys as if they were little girls—until about the age of four. (Courtesy of Sandy Lynch.)

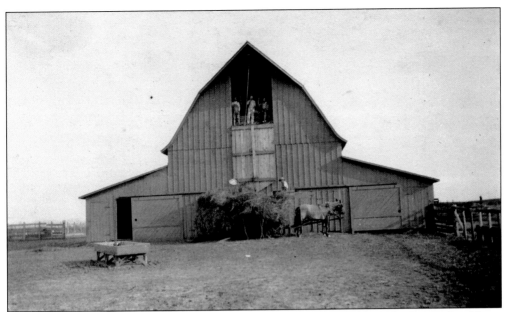

CLOVER HAY HARVEST, 1918. Standing in the hayloft are, from left to right, Roy Fickes, Harve Couch, and ? Allen. They are preparing to hoist hay from the wagon below, which is driven by Maurice Thompson. The day must have been a cool one, for the horse is wearing a blanket. (Courtesy of Sandy Lynch.)

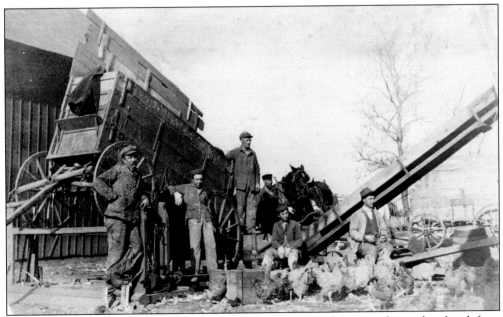

SHUCKING CORN, 1917. Workers on the Roy Fickes farm outside Warrensburg take a break from shucking corn as the chickens gather around to peck at stray kernels. Chickens were a common sight on Macon County farms until about 1950. (Courtesy of Sandy Lynch.)

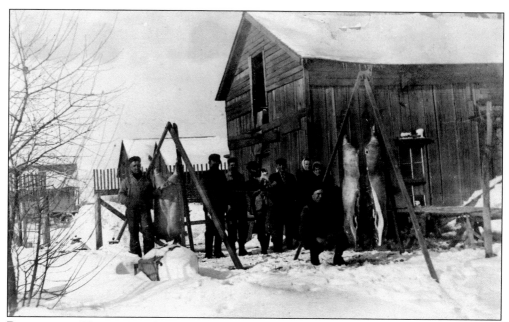

BUTCHERING HOGS, 1918. Hogs were commonly butchered in the dead of winter in order to preserve the meat from spoiling, as in this picture, taken on the Roy Fickes farm. Butchering was something of a social event, too, since many hands were needed to slaughter, dress, grind, salt, cook, and otherwise prepare the finished pork products. (Courtesy of Sandy Lynch.)

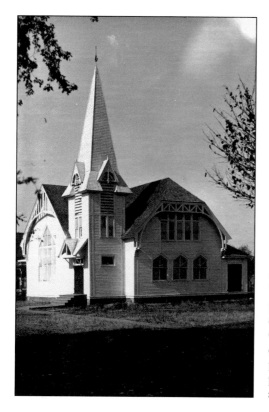

CONGREGATIONAL CHURCH, WARRENSBURG. Taken about 1905, this photograph highlights the hip roof and dramatic steeple of the Congregational Church of Warrensburg. Charles L. Wasson of the International Stereograph Company probably took the picture because of its perfect composition and balancing of light and shadow. (Courtesy of Pat Riley.)

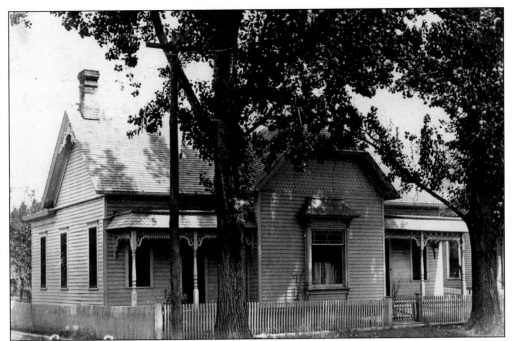

CONGREGATIONAL PARSONAGE. This parsonage, with its double porches, seems quite cozy and comfortable. The "gingerbread" trim, cedar shake roof, and picket fence make it an archetype for the prairie cottage of the day. (Courtesy of Pat Riley.)

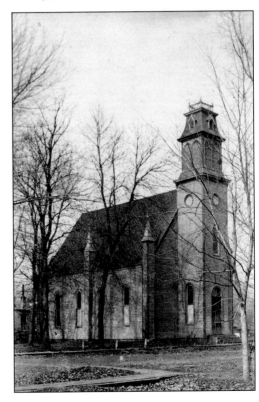

WARRENSBURG CHURCH OF GOD. The Church of God was one of the smaller denominations in Macon County. The Church of God maintained another, very small church in Boling Springs, near Forsyth. This photograph dates to about 1910. (Courtesy of Barclay Public Library.)

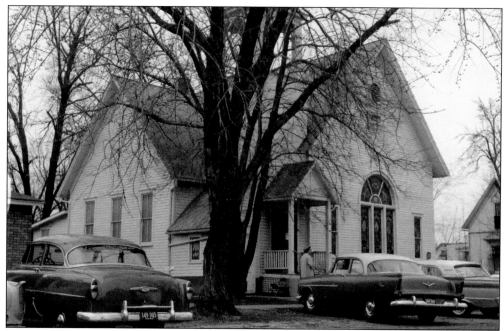

UNITED METHODIST CHURCH OF WARRENSBURG. The United Methodist Church of Warrensburg, photographed here in 1959, was formerly the Methodist Episcopal Church. A newer church has since replaced this building. Many Macon County congregations are in their second, or even third, church buildings. (Courtesy of Sandy Lynch.)

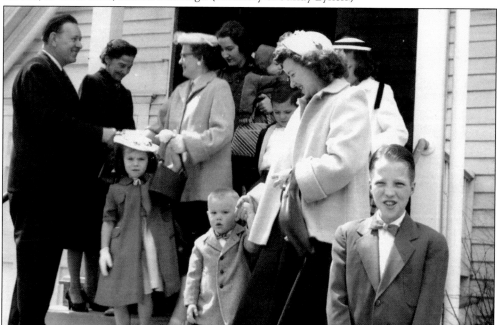

PASTORAL GREETINGS IN WARRENSBURG, 1959. The pastor of the United Methodist Church greets members of his congregation after a Sunday service. This scene is symbolic of all the close-knit rural church congregations that helped to create Macon County. Everyone is wearing his or her Sunday best. (Courtesy of Sandy Lynch.)

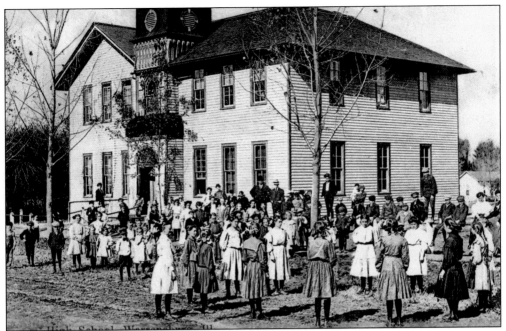

WARRENSBURG HIGH SCHOOL, 1913. The building in this picture was actually torn down in 1917 to make way for a new school. This postcard was produced by C. A. Dresbach of Warrensburg, but it was actually printed in Germany, as were many cards before World War I. (Courtesy of Barclay Public Library.)

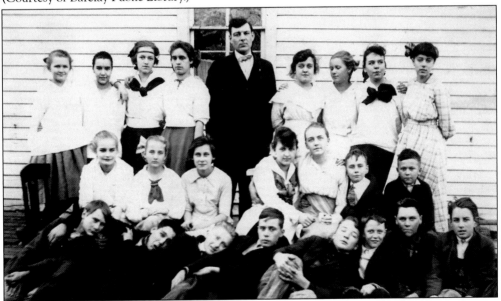

WARRENSBURG SCHOOL, 1917. Shown here from left to right are (first row) Russell Dickerson, Harry Wharton, Gerald Underwood, John Williams, Lewis Albert, Irvin Schroeder, Cyrus Baker, and Elston Hursh; (second row) Maud Williams, Margaret Dewin, Helen Ingham, Aliene Albert, Catherine Schroeder, Victor Dewin, and Ennis Peas; (third row) Mildred Phillips, Mary Hensley, Mildred Schroeder, Ruby Williams, J. Ives (teacher), Annabel Abston, Agnes Nottelman, Kathryn Shettel, and Mildred Herod. (Courtesy of Barclay Public Library.)

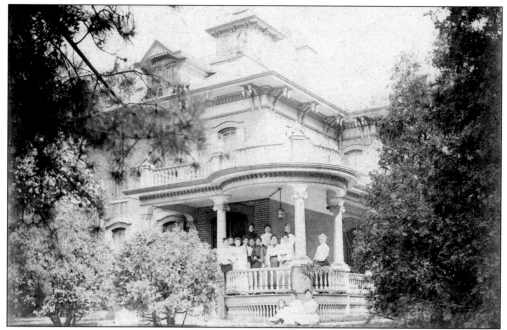

THE RITCHIE HOME, 1909. Vanna Virginia Ritchie, wife of William Ritchie, hosted an elegant garden party for the Cerro Gordo Ladies Club on July 22, 1909, in her stately Victorian home on the edge of Warrensburg. The Ritchie family was one of the most affluent in all of Macon County. (Courtesy of Barclay Public Library.)

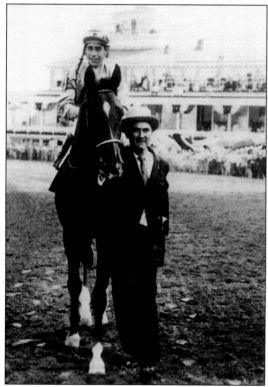

JOHN L. ROTZ, JOCKEY. John L. Rotz of Warrensburg is shown here winning the Preakness in 1962. He went on to win the Belmont Stakes in 1970. Rotz is one of the most famous jockeys in America and one of the most famous people in Macon County. (Courtesy of John L. Rotz.)

Three

MAROA, EMERY, AND FORSYTH

Named after the Tamaroa Indians, Maroa was founded in 1854, the same year that the Illinois Central Railroad arrived, guaranteeing access to markets for grain and cattle. The G. J. Schenck family appeared soon thereafter and built the first house in Maroa. The Schenck family later employed many people in their cigar factory. One of the early farmers was George Johnston, who had emigrated from Dumfrieshire, Scotland. Other early settlers included John M. Foukes and George B. Short. Maroa's Prairie Hotel was built in 1857. The Presbyterian Church was established in 1859, and the Christian Church in 1862. By 1900, Maroa was a bustling and expanding community, second only to Decatur in economic and cultural status. Maroa boasted of stables, hardware stores, a bank, a dry goods store, photography studios, a grain elevator, and an opera house. By 1905, Maroa had a thriving automobile dealership, a sure sign of the community's upward mobility. The very next year, 1906, the Illinois Traction System arrived, offering Maroa quick and reliable connections to destinations throughout the county. Although many fires raged through downtown Maroa in the years before World War I, largely because of wooden buildings, the town celebrated its obvious growth with a town auction in 1912, and a Fourth of July parade in 1913, featuring touring cars festooned with flags and colorful bunting. Maroa even fielded a semi-professional ball club, which in 1915 was led by the legendary Charlie Dressen.

Emery, an Illinois Central Railroad station, is located a few miles south of Maroa. By World War II several hundred people lived in the hamlet. Emery had its own school as well as a very active women's club.

Forsyth, originally spelled "Forsythe," was not actually incorporated until 1958, although John Hanks, a distant cousin of Lincoln, moved there in 1828, and the infamous bank robber Black Bart lived in Hickory Point Township before the Civil War. Forsyth boomed after the creation of the Hickory Point Mall in 1978, and it is now one of the fastest growing areas in Macon County.

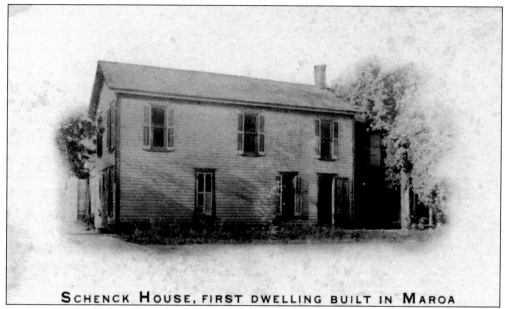

SCHENCK HOUSE, FIRST DWELLING BUILT IN MAROA

THE SCHENCK HOUSE. The Schenck family built the very first house in Maroa about the year 1850. Later a church was built on the same site about 1900. The Schencks became one of the leading families in Maroa, largely because of their cigar business. (Courtesy of Larry Nix.)

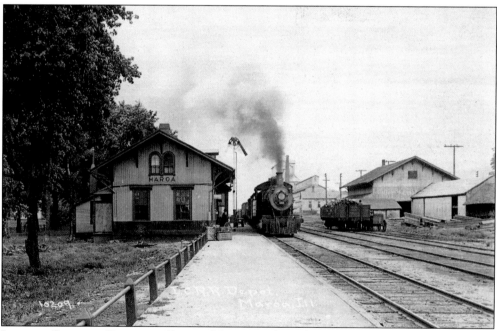

ILLINOIS CENTRAL RAILROAD DEPOT, MAROA. Taken about 1910, this photograph shows a man with baggage waiting on the platform. The depot has a second floor with living quarters for the station master—an unusual feature at the time. (Courtesy of Pat Riley.)

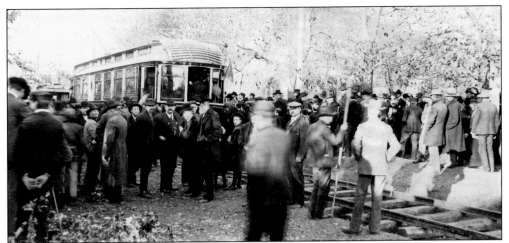

ILLINOIS TERMINAL RAILROAD, 1906. When the interurban first appeared in Maroa in 1906, it drew a large and curious crowd. Suddenly Decatur and Clinton were only a few minutes away for a round-trip fare of about 1½¢ per mile. (Courtesy of Decatur Public Library.)

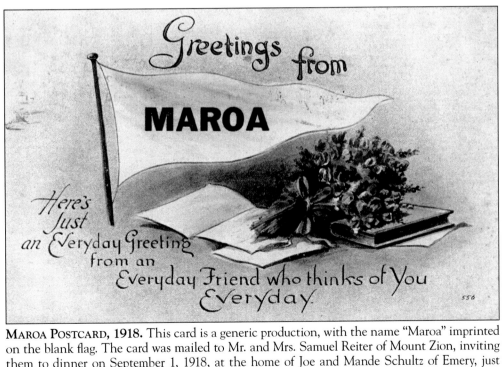

MAROA POSTCARD, 1918. This card is a generic production, with the name "Maroa" imprinted on the blank flag. The card was mailed to Mr. and Mrs. Samuel Reiter of Mount Zion, inviting them to dinner on September 1, 1918, at the home of Joe and Mande Schultz of Emery, just outside Maroa. (Courtesy of Larry Nix.)

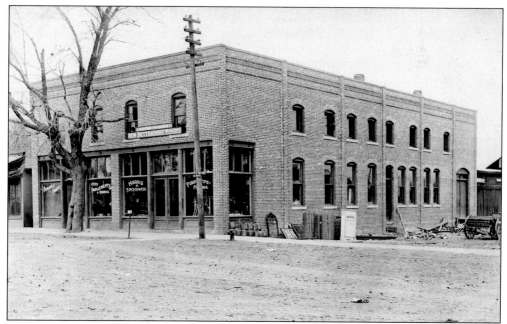

HARRIS AND SPOONER HARDWARE, 1911. Harris and Spooner Hardware sold buggies, surreys, wagons, farm implements, and plumbing supplies. Part of the Harris and Spooner building space was also used as the city jail. Note the pole for electricity directly in front of the building. (Courtesy of Larry Nix.)

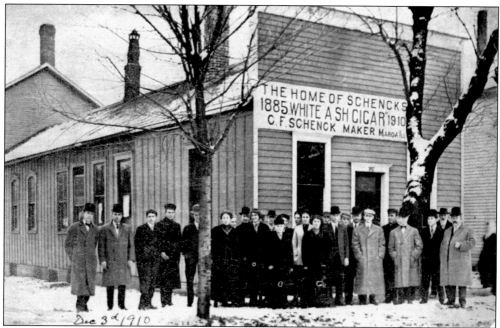

SCHENCK CIGAR COMPANY, 1910. C. F. Schenck made a considerable fortune from selling his "White Ash" cigars. Cigars were very popular, and Decatur had over 300 cigar shops. Schenck's office staff and production crew all pose for this picture on a snowy December day in 1910. (Courtesy of Larry Nix.)

SCHENCK CIGAR CLIPPINGS. This little bag once contained "screened cigar clippings," an inexpensive form of pipe tobacco that could be purchased for a fraction of the regular price. There was no waste at the Schenck Cigar Company in Maroa. (Courtesy of Larry Nix.)

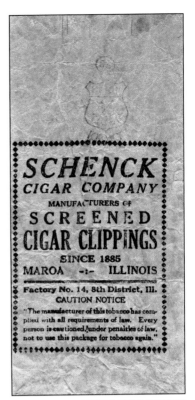

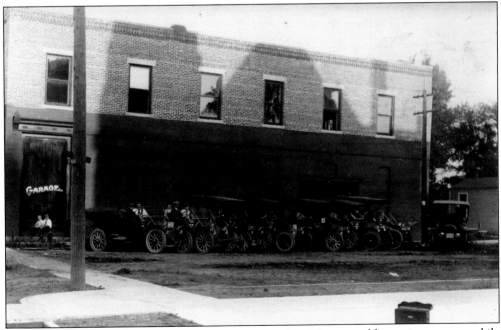

MAROA AUTOMOBILE DEALERSHIP. The very fact that Maroa could sustain an automobile dealership with a large inventory suggests the fundamental economic security of the community. On the lower left side of the picture, under the Garage sign, are two boys on bicycles. (Courtesy of Larry Nix.)

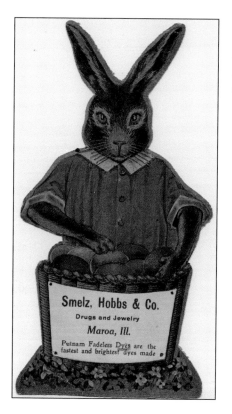

SMELZ, HOBBS, AND COMPANY. This Easter rabbit card from about 1905 doubled as an advertisement for Smelz, Hobbs, and Company, which had long sold drugs and jewelry to the patrons of Maroa. The company was founded in 1888 and operated until 1948, when it burned down. It was never rebuilt. (Courtesy of Larry Nix.)

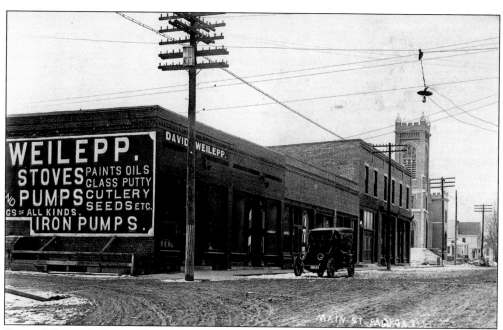

DAVID WEILEPP'S STORE. David Weilepp was one of the best-known merchants in downtown Maroa. This photograph, taken on a snowy day around 1910, shows the Weilepp store on the left side, before the great fire of 1913 left it in shambles. (Courtesy of Larry Nix.)

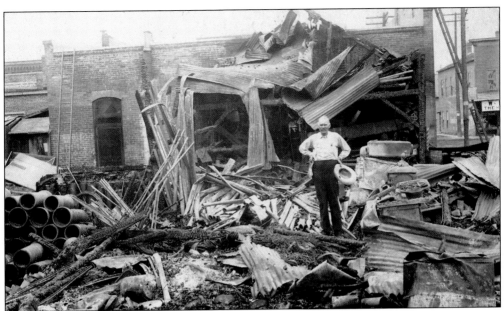

Maroa Fire of 1913. Prominent businessman David Weilepp is seen here, standing in the ruins of his former business after the tragic and devastating fire of 1913. Weilepp sold hardware, seeds, paint, plumbing supplies, and stoves. The business was a total loss. (Courtesy of Larry Nix.)

King Quality, - 35c Queen Quality, 30c
Blend, - - 25c Combination, - 20c
Swiss Villa, 38c
Grande M & J Blend 40c

The demand for **KAR-A-VAN** has compelled me to order another **Rush Shipment** which will arrive in time for Saturday trade. Let me have your order for one pound of any grade. I guarantee perfect satisfaction or money refunded.
Remember the brand, **KAR-A-VAN** That Rich, Creamy Kind
C. F. Crum, Maroa, Ill., Phone No. 34

Kar-A-Van Candy. Around 1905, Maroa merchant C. F. Crum was selling Kar-A-Van Candy, a confection that was apparently made from a mixture of vanilla flavoring and Karo Syrup. Like most rural subscribers at the time, C. F. Crum had a two-digit telephone number. (Courtesy of Larry Nix.)

JOHN KEMPSHALL. The gentleman standing in the doorway on the left side of the picture is John Kempshall, the only Confederate veteran to be buried in the Maroa cemetery. The taller white building on the right is the barbershop, and David Weilepp's store can be glimpsed in the background. (Courtesy of Larry Nix.)

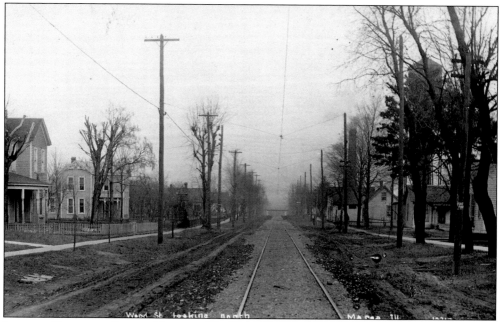

ILLINOIS TRACTION SYSTEM TRACKS. The Illinois Traction System provided service in Maroa from 1906 to 1953. The town of Maroa was listed in *Ripley's Believe It or Not* because, although roads crossed the tracks in three different places, the tracks were all northbound. Southbound tracks did not intersect with any city street. (Courtesy of Larry Nix.)

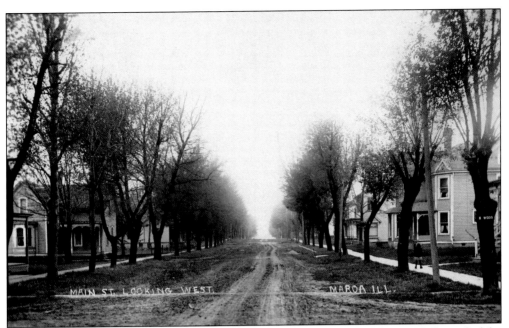

MAIN STREET, MAROA. The camera is pointed due west, and the empty space at the end of the street is the wide open prairie. On the right side of the picture, a little girl is trying out her roller skates on the smooth sidewalk that borders muddy Main Street. (Courtesy of Larry Nix.)

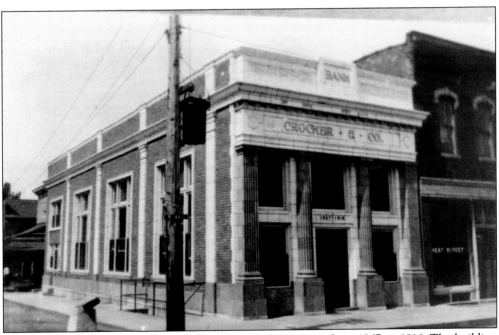

THE CROCKER BANK. The Crocker Bank operated in Maroa from 1867 to 1916. The building became a community landmark and, although the name has changed, it is still used as a bank today. The cannon on the left was melted down and used as part of the war effort in World War II. (Courtesy of Larry Nix.)

THE GIMLET. This little magazine was distributed free of charge to customers of hardware stores in 1913, like the patrons of J. G. Linville hardware store in Maroa. The publication contained lithographs, articles, and advertisements for tools and hardware. (Courtesy of Larry Nix.)

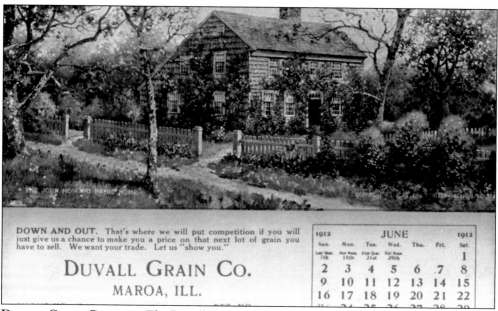

DUVALL GRAIN COMPANY. The Duvall Grain Company used this calendar card to advertise its prices for June 1912: white corn, 75 ¢; yellow corn, 72 ¢; oats, 52¢; wheat, $1.10. The prices listed were for bushels. (Courtesy of Larry Nix.)

Dear Friend:
 Next time ask us to show you our "Decatur Petticoats". Beautiful assortment just received Style, quality and prices will please you.
 "Decatursilk" Petticoats look and rustle like silk, wear three times as long and cost only one-fourth as much. Exclusive, smart styles at $1.50, $2.00, $2.50 and $3.00.
 Very truly,
 J. T. Keatts,
 Maroa Illinois

No, Dear, it's not silk; it's Decatursilk

J. T. KEATTS ADVERTISEMENT, 1910. Although the petticoats being advertised here were manufactured in Decatur, they were sold locally by such merchants as J. T. Keatts of Maroa, a good example of the economic symbiosis between the county seat and the outlying townships. (Courtesy of Larry Nix.)

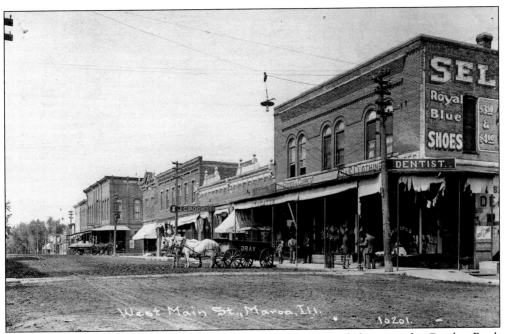

WEST MAIN STREET, 1906. The dray horses are waiting patiently between the Crocker Bank and J. T. Keatts, which sold dry goods, carpet, clothing, and groceries. In the 1906 economy, a pair of Royal Blue Shoes could be had for $3.50. (Courtesy of Larry Nix.)

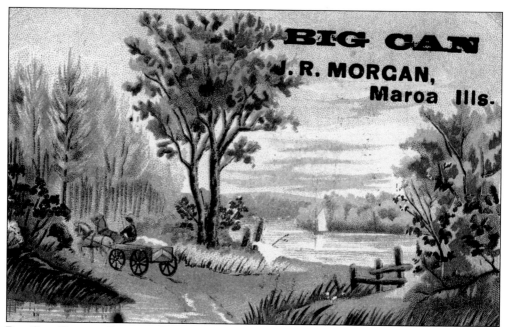

BIG CAN BAKING POWDER. Big Can Baking Powder offered its customers one and one half pounds of product for the price of one pound—hence, the name "Big Can." It was sold at J. R. Morgan's store in Maroa. The advertisement card dates to about 1910. (Courtesy of Larry Nix.)

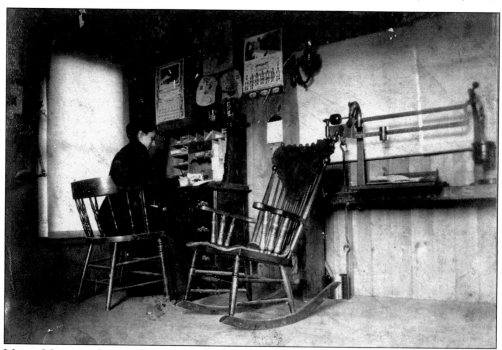

MAUD MILLER. The grain elevators were the very center of economic life in Maroa, and this photograph shows the interior of the grain elevator office, with employee Maud Miller working diligently at her desk. Note the large scale at the right. The photograph is dated January 1898. (Courtesy of Sandy Lynch.)

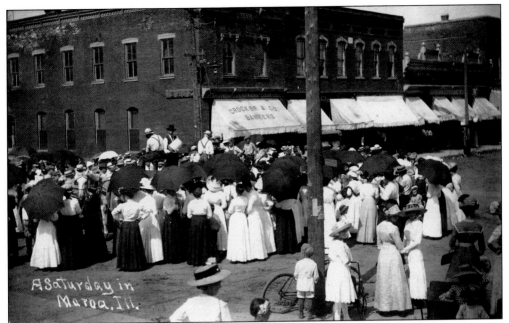

SATURDAY AUCTION IN MAROA, 1912. On a warm Saturday morning in August 1912, the ladies and children of Maroa turned out for this auction. This corner location, next to the Crocker Bank, would have been the center of town at the time. (Courtesy of Larry Nix.)

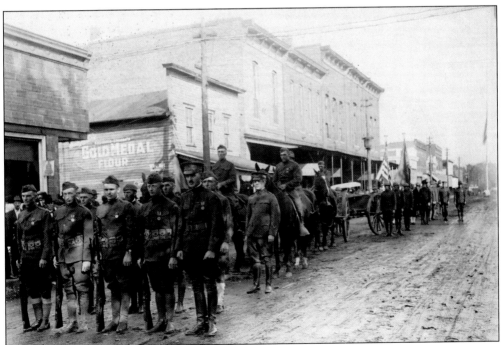

FUNERAL MARCH, 1920. These doughboys are marching through downtown Maroa on a dreary day in 1920 as they mourn the passing of their fallen comrade Stanley Cramer. The soldiers are all wearing their campaign medals. (Courtesy of Larry Nix.)

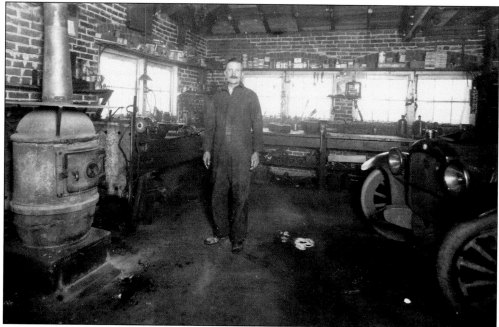

DAVIS AUTO GARAGE. Dan Davis operated the Davis Auto Garage on West Washington Street in Maroa. Early automobiles required frequent and loving attention from their mechanics. Davis is standing next to his bench grinder, tools, and spare parts in this early-1920s photograph. (Courtesy of Sandy Lynch.)

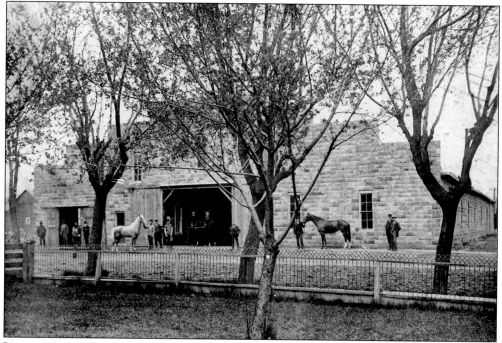

LIENHART STABLES. Grooming and feeding horses, especially those for hire, were typical activities in farming towns around 1900. The site became the location of the M and M Café. (Courtesy of Larry Nix.)

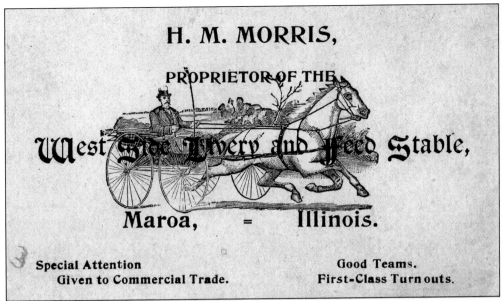

H. M. MORRIS,

PROPRIETOR OF THE

West Side Livery and Feed Stable,

Maroa, = Illinois.

Special Attention
Given to Commercial Trade.

Good Teams.
First-Class Turnouts.

WEST SIDE LIVERY AND FEED STABLE. Before the advent of the automobile, Macon County could have been accurately described as an equine-based culture. Many stables were needed to keep the horses in fit condition. All of that changed with the appearance of the Model T in 1908. (Courtesy of Larry Nix.)

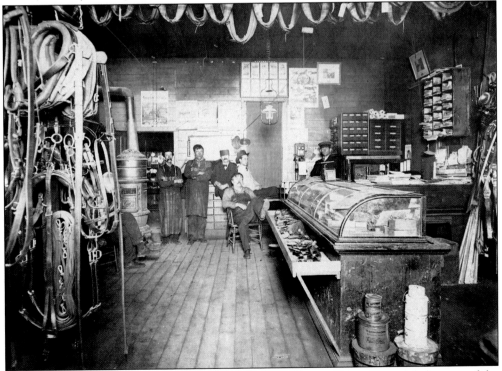

HAFFEY HARNESS SHOP. Haffey's shop sold collars, bridles, and bits, all crucial elements of the local farm economy. The shop also carried cans and buckets of axle grease, which can be seen stacked together in the right-hand corner of the photograph. (Courtesy of Larry Nix.)

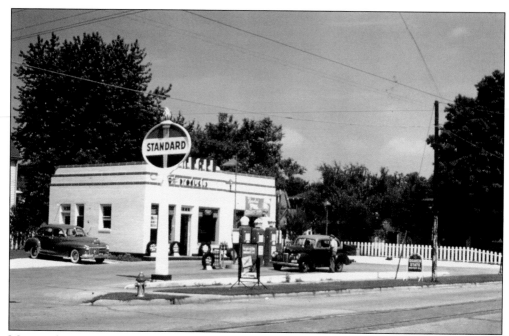

MAROA STANDARD STATION, 1949. This station was a fixture in the age of the "horseless carriage." The sedan on the left is a Chevrolet and the car at the pump is a Nash. "Service" station still meant service with a uniformed attendant when the photograph was taken in July 1949. (Courtesy of Larry Nix.)

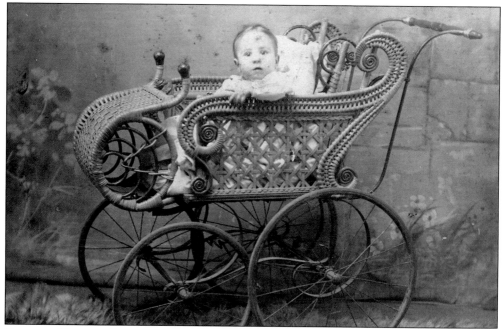

BABY IN WICKER CARRIAGE. This unidentified baby was photographed in the Donnelly Studio of Maroa about 1895. The fancy carriage may have been a photographer's prop. Baby pictures have been a part of American memorabilia since the time of the Civil War. (Courtesy of Sandy Lynch.)

BABY IN CHRISTENING GOWN, 1894.
This unidentified baby was brought
to the Jenkins Studio of Maroa to be
formally photographed after a christening
ceremony in 1894. The oversized
christening gown was considered stylish
at the time. (Courtesy of Sandy Lynch.)

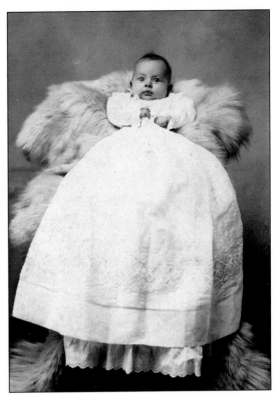

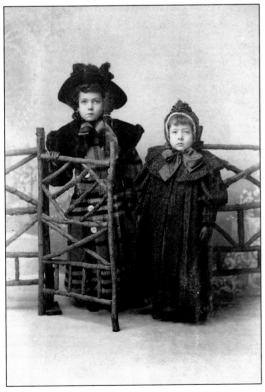

SISTERS IN WINTER GARB, 1893. These
two sisters posed in their winter finery
when their portrait was made in the
Jenkins Studio of Maroa in 1893. The little
girl on the right does not seem overjoyed
at the prospect of being photographed.
(Courtesy of Sandy Lynch.)

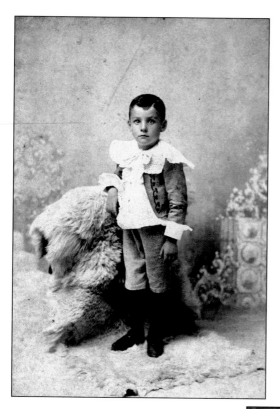

PORTRAIT OF JIMMY ARMSTRONG. Little Jimmy Armstrong posed for this portrait around 1895. It is hard to imagine how a normal lad of the time would keep an elaborate lace shirt and collar clean and neat for any period of time. (Courtesy of Sandy Lynch.)

TWINS WITH MATCHING FANS AND DRESSES, 1895. Black satin dresses with high necks and flounce sleeves represented the height of contemporary fashion in Macon County in 1895. The unidentified twins posed in the Jenkins Studio of Maroa. (Courtesy of Sandy Lynch.)

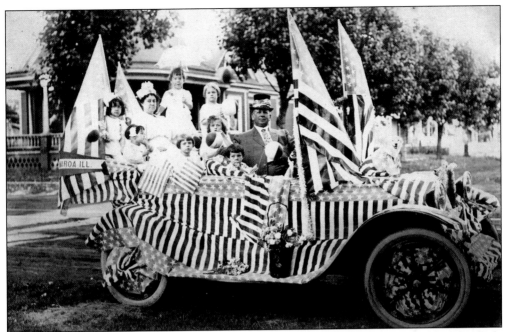

FOURTH OF JULY PARADE, 1913. This overly decorated car was an entry in the Fourth of July parade held in 1913. The driver of the car is Ed Hendrix. His unidentified wife is sitting in the back surrounded by seven neighborhood children, who probably never forgot the day. (Courtesy of Larry Nix.)

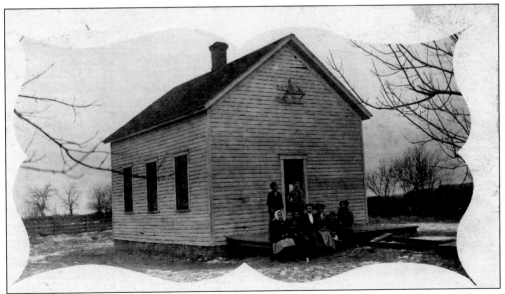

MILLER SCHOOL, MAROA. Seated on the porch are, from left to right, Fern Bennett, Jennie Bennett, Erma Bennett, Gertrude Munch (teacher), Oma Girard, Naomi Hunt, and Myrtle Pierce; standing are Aquilla Girard and Lawrence Hunt. (Courtesy of Pat Riley.)

MONTHLY REPORTS.

NAME *Virgil Leach* {4th yr. Class H.S. Grade.
{ Class Grade.
From Sept. 1909, to June 1910. *J. McLeod* Teacher.
From 19__, to 19__ Teacher.

REPORTS.	MONTHS.										AVGE.
	1st	2d	3d	4th	5th	6th	7th	8th	9th		
Deportment	90	85	85	90	80	85	90	90	95		
Industry	95	90	90	95	95	90	90	90	95		
Tardiness	0	0	0	0	0	0	0	0	0		
Attendance	21½	22	17½	17½	21½	18½	21	16	16		
Absence	0	1	½	½	½	1½	0	6	0		
EXCUSED	0	2	1	0	0	2	2	0	2		

VIRGIL LEACH'S REPORT CARD, 1910. Virgil Leach had a near-perfect attendance record in his senior year at Maroa High School, 1909–1910. That year he was enrolled in English IV, Physics, Geography, Arithmetic, and American History. He later attended the University of Illinois at Urbana-Champaign. (Courtesy of Sandy Lynch.)

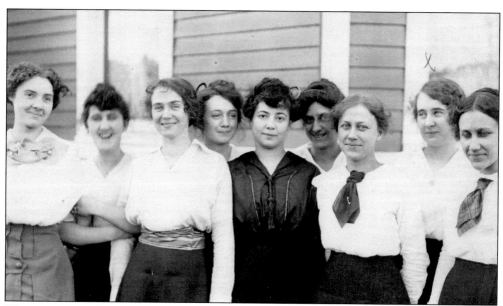

WOMEN OF THE CLASS OF 1914. These women graduates are, from left to right, Ella Shields, Alma Harris, Ruth Shields, Marie Brown, Laura Cottet, Ottie Morgan, Edna Jones, Alice Nowlin (marked with an X over her head), and Kate Jones. According to Alice Nowlin, this group called themselves the "Hello Girls." (Courtesy of Pat Riley.)

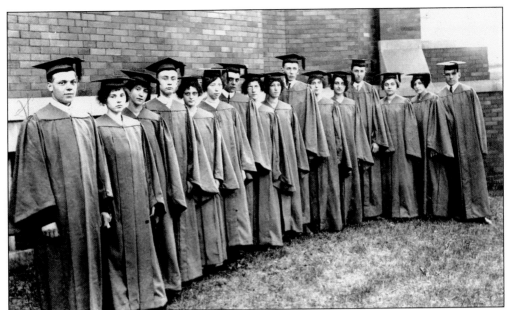

MAROA CLASS OF 1914. These graduates of Maroa High School, class of 1914, are suitably attired in caps and gowns as they pose for their group photograph near the entrance to the Maroa High School building. (Courtesy of Pat Riley.)

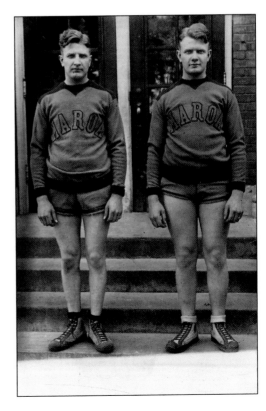

THE KAMMAYER BROTHERS. Charley (left) and Hurb (right) Kammayer were locally famous as the athletic brothers of Maroa High School. They are pictured here, about 1920, in their basketball gear and Maroa sweatshirts. (Courtesy of Larry Nix.)

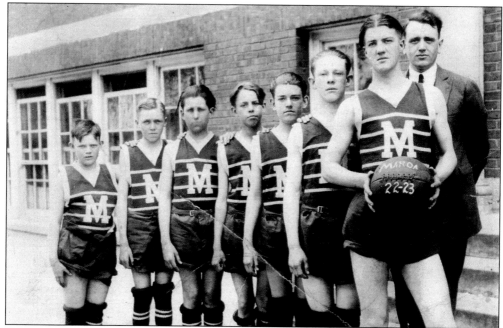

MAROA BASKETBALL TEAM, 1922. These unidentified team members represent the long and the short of the basketball squad from the 1922–1923 season. The coach is standing on the extreme right. Unlike today, the uniform shorts are held up with belts and buckles. (Courtesy of Larry Nix.)

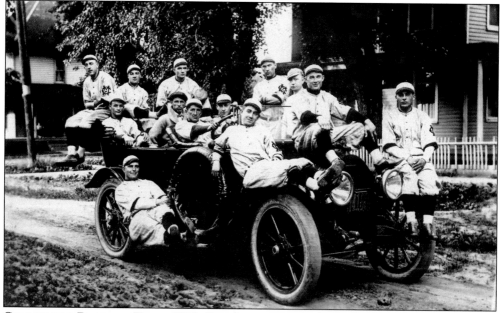

COMMERCIAL BASEBALL TEAM, 1915. Seen here sitting on the back of the car are, from left to right, Phil Redman, Wes Bowman, and Ross Bolen; inside the car, Charley Fenton, Dick Jones, Newell Harris, and Willard Jump; on running board, Doc Amman; on left front fender, Cliff Bolen; standing in the rear, Shorty Ellison and Rolla Moon; sitting on hood, Charley Dressen (pitcher); and on right front fender, Buster Cramer. (Courtesy of Larry Nix.)

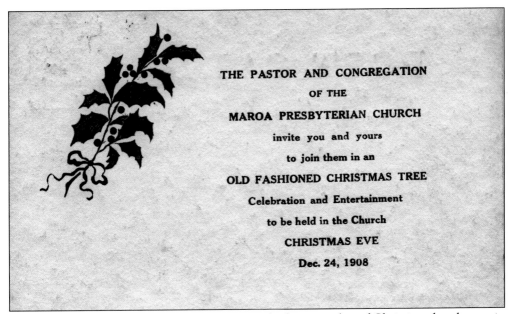

THE PASTOR AND CONGREGATION

OF THE

MAROA PRESBYTERIAN CHURCH

invite you and yours

to join them in an

OLD FASHIONED CHRISTMAS TREE

Celebration and Entertainment

to be held in the Church

CHRISTMAS EVE

Dec. 24, 1908

CHRISTMAS TREE CELEBRATION, 1908. Given the large number of Christian churchgoers in Macon County, it is not surprising that Christmas celebrations were elaborate, well-attended affairs, like this one at the Maroa Presbyterian Church on Christmas Eve 1908. (Courtesy of Pat Riley.)

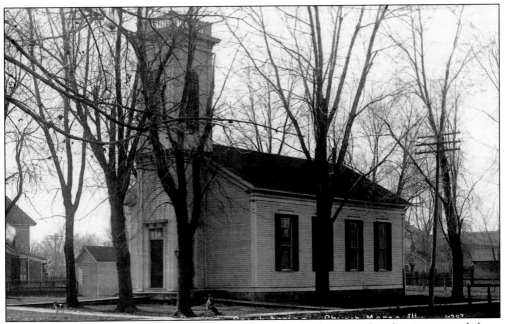

MAROA PRESBYTERIAN CHURCH. This picture shows the Presbyterian church as it appeared about 1905. This wooden building was later replaced by a more permanent brick edifice. Although there was usually one Presbyterian house of worship in each community, the Presbyterians were in the minority among the other protestant denominations of the county. (Courtesy of Pat Riley.)

83

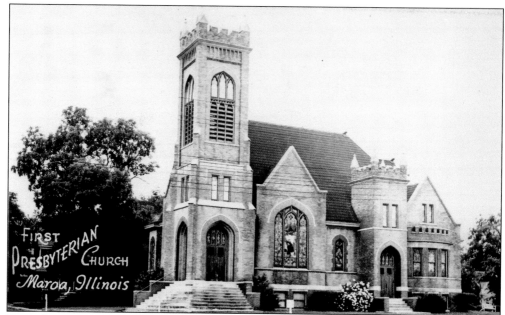

FIRST PRESBYTERIAN CHURCH OF MAROA. The Presbyterian Church and the Cumberland Presbyterians joined together to form a new denomination known as the Presbyterian Church, U.S.A. in the year 1910. Presbyterians from both groups had started congregations throughout Macon County. The Cumberland branch was particularly active in the Mount Zion area. (Courtesy of Pat Riley.)

MAROA METHODIST CHURCH. This Methodist church is an impressive edifice for a small town; it dwarfs the cottage barely seen on the lower left side of the photograph. This picture was taken in 1942, although the church dates back to the early part of the century. (Courtesy of Pat Riley.)

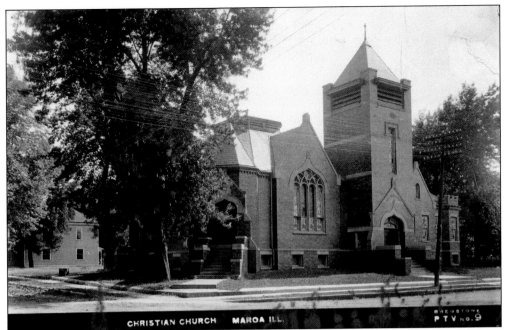

CHRISTIAN CHURCH MAROA ILL.

PTV No. 9

MAROA CHRISTIAN CHURCH. Along with the Disciples of Christ, the Christian Church was part of the Campellite movement, which sent many congregations to Illinois and the Midwest from the Northeast around 1900. Today there are numerous Christian Churches throughout Macon County. (Courtesy of Pat Riley.)

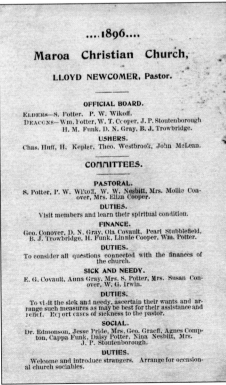

MAROA CHRISTIAN CHURCH, 1896. The congregation of the 1896 Maroa Christian Church was very well organized under the leadership of Lloyd Newcomer, the pastor. The reverse side of this card lists "prayer meeting topics" for each Sunday, with appropriate scriptural readings. (Courtesy of Larry Nix.)

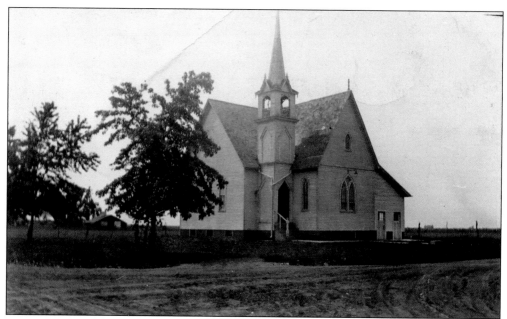

UNITED BRETHREN CHURCH. Although the United Brethren denomination was spread rather sparsely through Macon County, a distinctive and beautiful church was constructed in the very rural Harmony area outside Maroa. The church thrived there during the early decades of the 20th century. (Courtesy of Larry Nix.)

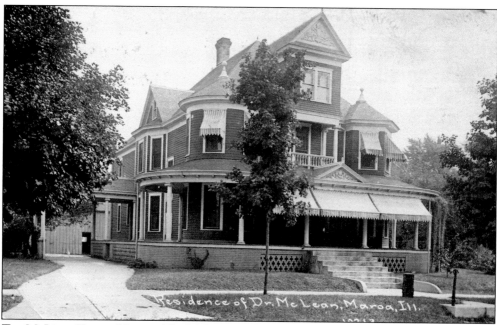

THE MCLEAN HOUSE, MAROA. The McLean residence, a good example of Victorian architecture, boasts striped awnings, turrets, broad porches, decorated pediments, and a curved driveway. It was one of the finest dwellings in Maroa when this photograph was taken in 1915. (Courtesy of Larry Nix.)

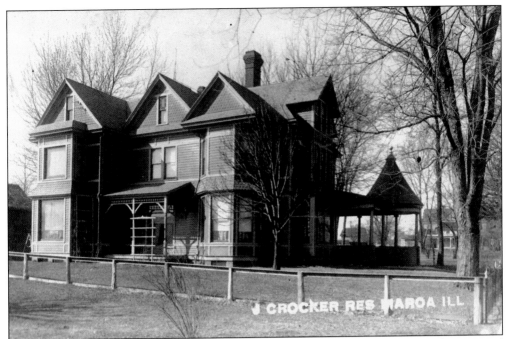

JOHN CROCKER RESIDENCE. This three-story, wooden frame Victorian house with a turreted front porch was an appropriate dwelling for the Maroa community's most famous and influential banking family. The photograph was taken about 1910. (Courtesy of Larry Nix.)

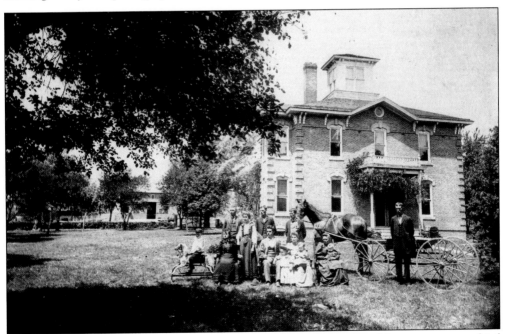

SAMUEL J. HANKS. Samuel J. Hanks, the man seated in the center of this group, was a third cousin of Abraham Lincoln. The other people in the picture are not identified. The fine brick house in the background was built in 1880 but destroyed by fire in 1930. (Courtesy of Sandy Lynch.)

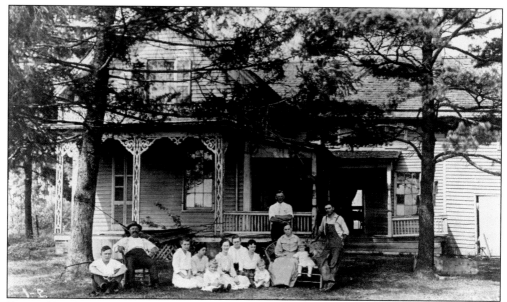

RALPH REYNOLDS'S HOME. In this family photograph taken about 1915, the Ralph Reynolds family of rural Maroa poses in front of the home they had owned since 1863. The two men standing are, on the left with arms folded, Benton Jones and, on the right wearing overalls, Ralph Reynolds. (Courtesy of Rosemary Malone.)

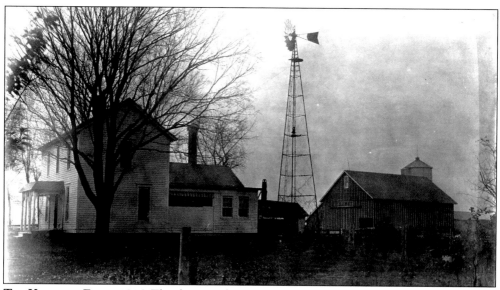

THE KERWOOD FARM, 1916. This farmstead is a typical Macon County arrangement: a two-story house with a small front porch and a long attached kitchen in the back, a barn, outbuildings, and the indispensable windmill to pump the farm's water. (Courtesy of Pat Riley.)

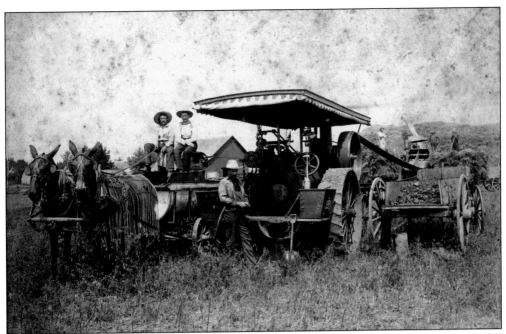

THRESHING WHEAT, 1910. Wheat is being threshed on this unidentified Maroa farm in the fall of 1916, using a coal-fired boiler to power the machinery. The coal wagon is parked to the right of the thresher, and the mules on the left are wearing leather "fly nets" to help shake off flies and other insects. The mules are pulling the water tank. (Courtesy of Sandy Lynch.)

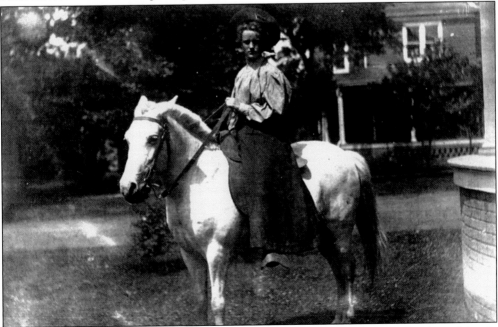

LOUISE GENTLE ON HORSEBACK. Louise Gentle, one of the best-known people in historic Maroa, is shown here posing on horseback about 1910, when she was 18 years old. Louise Gentle lived to be 100 years old. She recorded many of her memories, and these were printed during the Maroa sesquicentennial in 2004. (Courtesy of Larry Nix.)

MAROA NOVELTY CARD. A generic postcard like this one, with the town name imprinted over the original design, was very popular in the early years of Maroa. This card also has something of a humorous twist. It was mailed on March 3, 1915. (Courtesy of Larry Nix.)

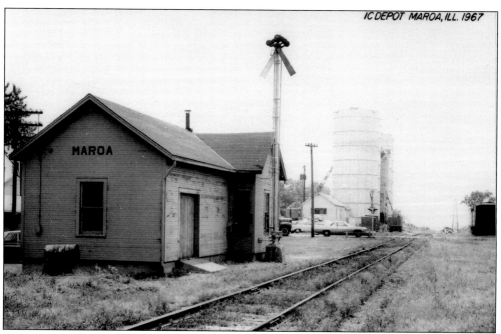

ILLINOIS CENTRAL RAILROAD DEPOT, 1967. This depot, which had once been the focal point of the commercial and community life of Maroa, was now a lowly freight station. Eventually the Illinois Central Railroad would relocate its tracks coming into Maroa, marking the end of an era. (Courtesy of Larry Nix.)

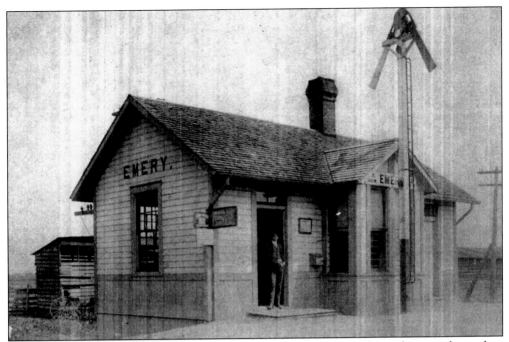

ILLINOIS CENTRAL RAILROAD DEPOT, EMERY. The small station at Emery became the nucleus of a busy little hamlet with a grain elevator and school. This train station is identical in design to the one built on the same tracks a few miles south in Forsyth. (Courtesy of Pat Riley.)

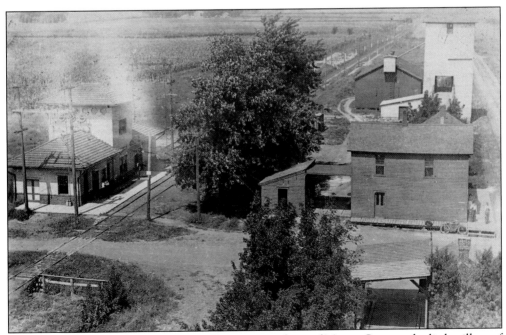

BIRD'S-EYE VIEW OF EMERY, ILLINOIS. For many residents of Macon County, the little village of Emery was truly just a "dot on the map." But as this bird's-eye view shows, around 1920, Emery had a grain elevator and even an interurban depot, which is the white building on the left with the tiled roof. (Courtesy of Pat Riley.)

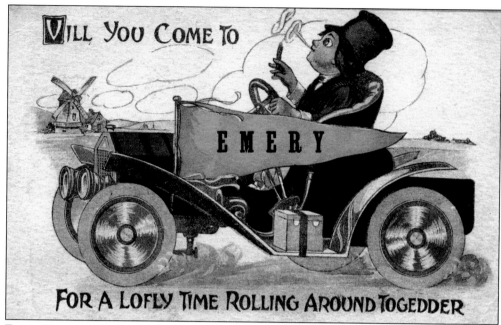

EMERY NOVELTY CARD, 1915. The German brogue of the driver highlights the fact that there were many German immigrants in Macon County at this time—and even a German-language newspaper. On the reverse side is a message from W. A. Davenport: "Highest prices paid for all country produce." (Courtesy of Larry Nix.)

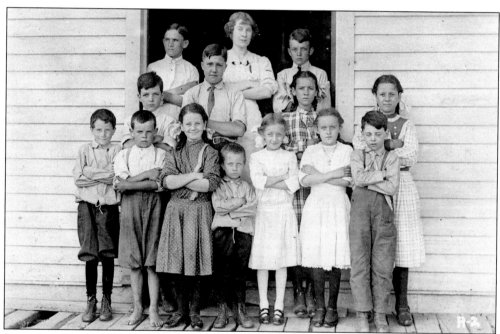

FAIR PLAY SCHOOL, EMERY, 1912. The only person identified in this school photograph is the teacher, Effie Sturges, who is standing in the center of the back row. Oddly, all the pupils are posing with arms folded, and the little boy in front, second from the left, apparently forgot to wear his shoes. (Courtesy of Rosemary Malone.)

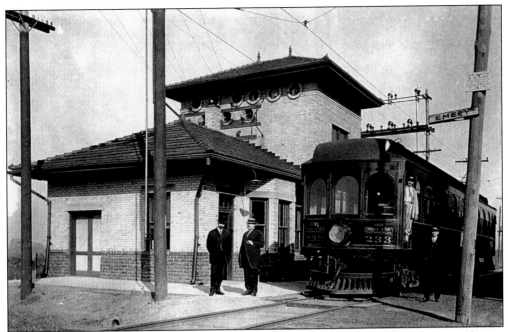

ILLINOIS TRACTION SYSTEM DEPOT, EMERY. A pair of well-dressed gentlemen and two conductors pose next to the Illinois Traction System office car in Emery around 1910. The car ran on electric motors that were powered from the cables overhead. (Courtesy of Forsyth/Hickory Point Township Historical Society.)

SOUVENIR BOOKLET, 1919. This memory booklet records the 1909 school year at Fair Play School in Emery. There were 33 students, all taught by Roberta Engelhardt, who apparently chose the verses from Heine on the cover of the booklet. (Courtesy of Rosemary Malone.)

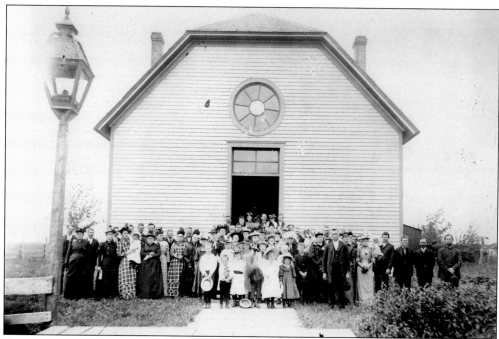

CENTER RIDGE CONGREGATION. This group picture of the Center Ridge Church was taken about 1905 after a Sunday service. The members of the congregation cover all the age brackets, showing the highly social nature of church life. Center Ridge Church was located between Maroa and Argenta. (Courtesy of Larry Nix.)

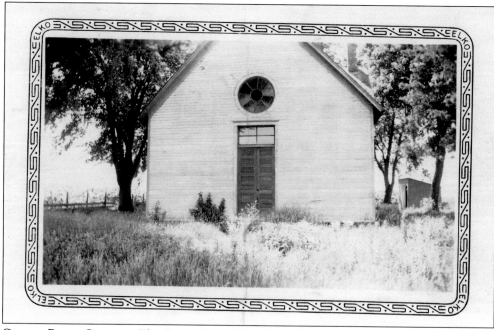

CENTER RIDGE CHURCH. The Center Ridge Church, with its distinctive circular window, seems weedy and abandoned in this photograph taken about 1925. The small building to the right of the church is an outhouse. (Courtesy of Larry Nix.)

EMERY MONUMENT. The World War I soldier standing at attention marks the double grave site of Charles and Walter Emery, who both died in that war. The Emery family gave its name to the nearby small community, which now consists of a train stop and a grain elevator. (Courtesy of Doug Imboden.)

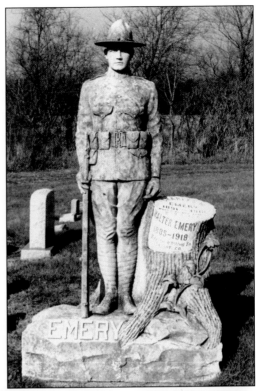

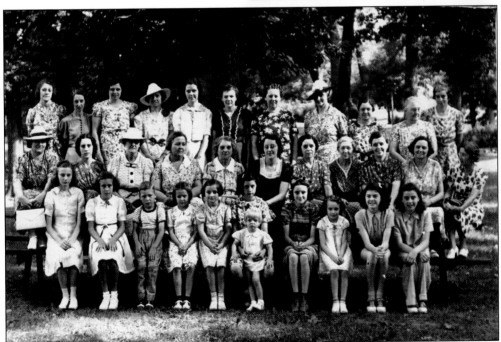

EMERY HOUSEHOLD CLUB, 1939. This club promoted social bonding among all ages of women and girls in the Emery-Maroa area. In 1939, the Household Club celebrated its 26th anniversary with a party in Fairview Park, Decatur. (Courtesy of Rosemary Malone.)

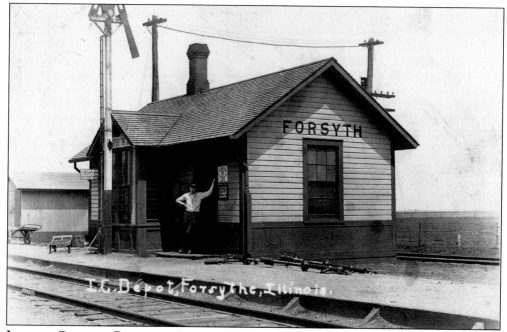

ILLINOIS CENTRAL RAILROAD DEPOT, FORSYTH. The two small signs on the wall of the depot advertise service for Western Union Telegraph and Cable and for the American Express Company. The attendant is leaning against the wall on a slow day around 1910. (Courtesy of Pat Riley.)

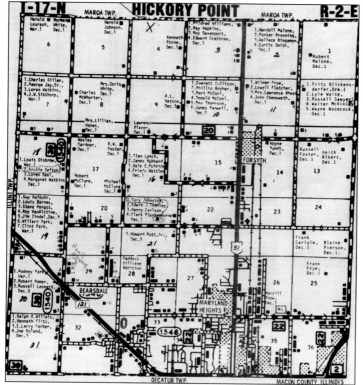

PLAT MAP OF HICKORY POINT TOWNSHIP. This agricultural plat was drawn in 1974, about four years before Hickory Point Mall was built in Forsyth, an addition that allowed the village to reap great tax benefits. Most of the land in and around Forsyth has since increased in value exponentially. (Courtesy of Dorothy Pugh.)

HENRY C. MOWRY, 1905. Henry C. Mowry was a prominent grain dealer in Forsyth whose grain elevator was purchased by the Shellabarger Company of Decatur, which was the major grain processor in Macon County at that time. Henry Mowry died in 1908. (Courtesy of Decatur Public Library.)

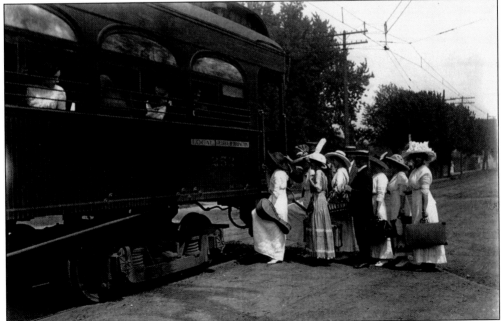

BOARDING THE INTERURBAN IN FORSYTH. About 1905, these fashionably dressed ladies and gentlemen are boarding the interurban for a recreational outing, including some tennis. The ladies sport the large chapeaux of the day, and the men are wearing straw "boaters." (Courtesy of Forsyth/Hickory Point Township Historical Society.)

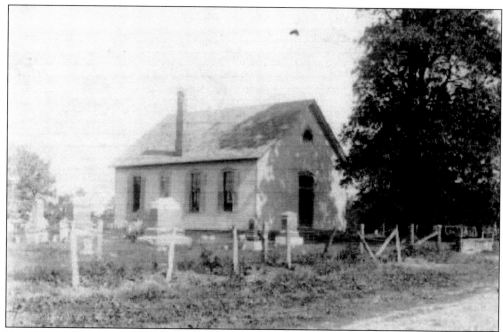

THE CHURCH OF GOD. The Church of God has always been one of the smaller denominations in Macon County, but it has had a presence in the county for over a century. This small building near Forsyth was the site of the first Church of God congregation outside Decatur. (Courtesy of Sandy Lynch.)

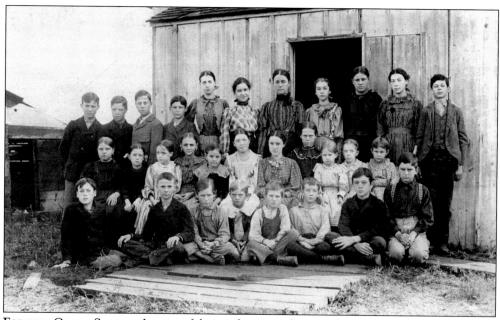

FORSYTH GRADE SCHOOL. In spite of the rough surroundings, as shown in this photograph taken about 1900, these unidentified Forsyth grade-schoolers are rather nicely turned out, displaying quite a variety of colors, fabrics, and patterns in their clothes. (Courtesy of Forsyth/Hickory Point Township Historical Society.)

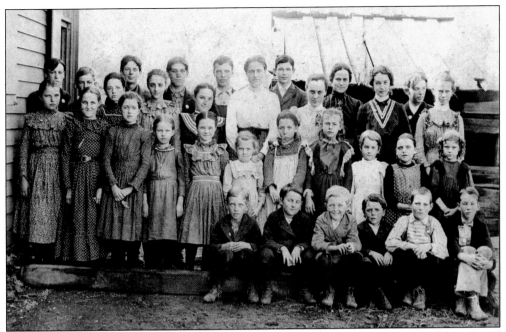

FORSYTH GRADE SCHOOL, 1903. In this school photograph, 30 unidentified Forsyth pupils and their teacher pose outside the school building. The only student that can be identified is Minnie Davis Orr, who is the fifth from the right, in the second row. (Courtesy of Forsyth/Hickory Point Township Historical Society.)

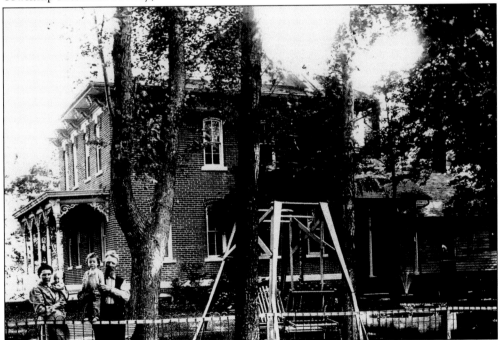

THE WEAVER HOUSE. In a family photograph taken about 1900, the Weavers are leaning against the fence of their property on Janvrin Road in Hickory Point Township outside Forsyth. The individuals are not identified. (Courtesy of Sandy Lynch.)

THE McCOOL FAMILY. The McCool family poses, in this 1898 photograph, on the Traver Farm outside Forsyth. They are, from left to right, George McCool, Lester McCool, Minnie McCool, Bert McCool (baby), and Ethel McCool. The hired man on the extreme right is unidentified. (Courtesy of Rosemary Malone.)

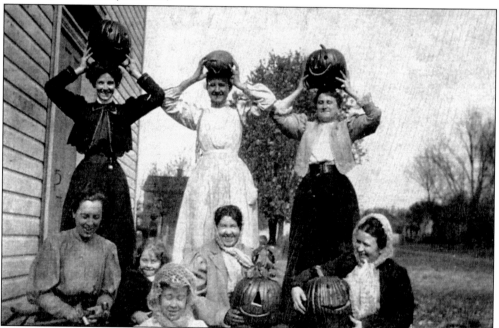

HALLOWEEN PARTY, 1907. On October 30, 1907, these Forsyth residents celebrated Halloween. They are, from left to right, (first row) Maude Benton, Ethel Hays (little girl), Bessie Lindsey (in front), Esther McKinley, and Ruth Lehman; (second row) Mayme Reeser, Mary Parkhurst, and Ann Stoll. (Courtesy of Sandy Lynch.)

LITTLE THEATER IN FORSYTH. In 1921, a Forsyth little theater group produced a Christmas play called *The Dream That Came True*. The cast numbered nearly 20 people, and the play was a real measure of the community spirit in Forsyth at the time. (Courtesy of Forsyth/Hickory Point Township Historical Society.)

The Dream That Came True

I. O. O. F. HALL—FORSYTH, ILL.
LADIES AID

November 11th and 12th, 1921

SCENE—A FACTORY TOWN
TIME—PRESENT DAY

ACT I—Parlor in Mrs. Jenkins' Boarding House, a week before Christmas.

ACT II—Living Room in the Norton Home, the day before Christmas.

ACT III—Sun Parlor in Norton Home, Christmas evening.

THE CAST

Nan Worthington—One of the People	Alma Pense
Gordon Clay—Foreman of the Works	Wm. Lemme
Margaret Byrnes—Loyal and True	Mary Rubbles
Mrs. Jenkins—Keeper of Boarding House	Esther Benton
Angelina Maud—Her Daughter	Nadine Glosser
Jack Brown—A Cub Reporter	Robert Berry
Miss Louisa Hawkins—One of the Boarders	Etta Bixler
Florabel Mullins—A Poetess	Lois Blazer
Miss Mehitabel Biddle—A Suffragette	Helen Earl
Bobbie Byrnes—Averse to College Women	S. J. Swarts
Emmy Lou Norton—Fond of Fairy Tales	Alice McKinley
Nora—A Maid	Milly Cooley
Delphine Norton—A College Graduate	Mrs. S. J. Swarts
Peggy Gilbert—A Browning Fiend	Etta Parlier
Billy Best—Captain of the Varsity Team	Joe Harmon
Mrs. Allaire—The Chaperone	Mrs. Mm. Lemme
Dorris Hall—An Athletic Girl	Flossy Gregory
Lord Algernon Reginald—Straight from England	John Earl
Charles Norton—Owner of the Works	J. J. Glosser

—WHAT—

Church Fair! Church Fair!

—WHEN—

I.O.O.F. Hall, Forsyth, Ill.

—WHERE—

Wednesday, Dec. 12, '28

2 P. M.—10 P. M.

O come all you folks, O come and you'll see
The things on display at our church jamboree.
There's product of farm and bak'ry goods, too,
There's ice cream in cones and cold drinks for you.
There's lunch on a plate and chilli that's hot,
There's pie and there's coffee right out of the pot.

There's things, with the needle the ladies have made,
Fancy caps, useful aprons and clothing displayed.
Nice things for the kitchen and bathroom on sale,
Fluffy things, muslin things, continues the tale.
White elephants to buy—a pond where you fish,
A program to hear—what more do you wish?

REMEMBER THE DATE

CHURCH FAIR, 1928. This announcement is for a church fair held at the Independent Order of Odd Fellows hall in Forsyth on December 12, 1928. The fair was evidently an effort to raise money for various charitable projects. (Courtesy of Forsyth/Hickory Point Township Historical Society.)

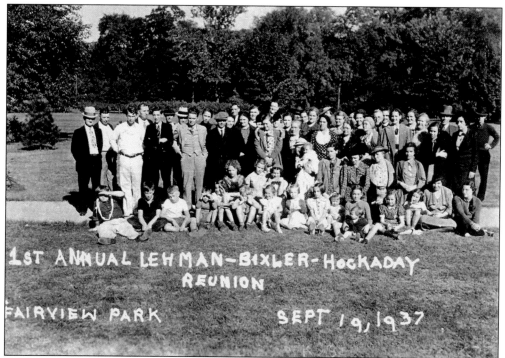

LEHMAN-BIXLER-HOCKADAY REUNION, 1937. Three Forsyth families gathered together in Decatur's Fairview Park for a combined reunion on September 19, 1937. Reunions have always been an essential part of the social network in Macon County and were often held in Fairview Park. (Courtesy of Sandy Lynch.)

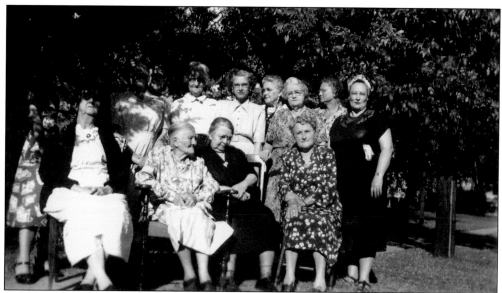

THE WOMEN'S CLUB, 1949. The Forsyth Women's Club met in September 1949 to celebrate the birthday of Mary Davis. Davis, the only identified person in the picture, is the lady in the white dress, seated on the left side of the front row. Clubs like this one were the mainstay of community life in Macon County. (Courtesy of Forsyth/Hickory Point Township Historical Society.)

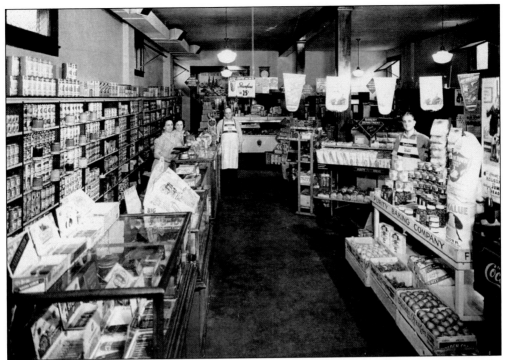

C. K. Cooper Grocery. The C. K. Cooper grocery store opened in 1918 and operated for several generations, providing groceries as well as postal service. Familiar brand names stock the shelves in this 1940 photograph. Standing are, from left to right, Ruth Fornwalt, Margery Cooper, C. K. Cooper, and Frank Cooper. (Courtesy of Sandy Lynch.)

Dr. Lucien Nelson Lindsey's House. The combined house and office of Dr. Lucien Nelson Lindsey was erected about 1920, and remains standing today. He and his wife Bessie were fixtures in the social life of Forsyth in the era between World War I and World War II. (Courtesy of Forsyth/Hickory Point Township Historical Society.)

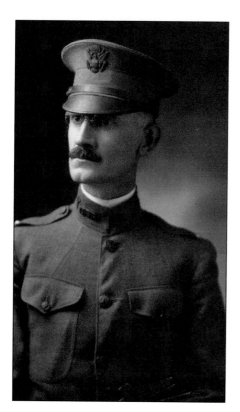

DR. LUCIEN NELSON LINDSEY. Dr. Lucien Nelson Lindsey began practicing medicine in 1905. He served in World War I, and this portrait shows him in uniform. He and his wife Bessie, whom he married in 1905, owned a nationally famous collection of old glass. He was on the staff of the Macon County Hospital. (Courtesy of Decatur Public Library.)

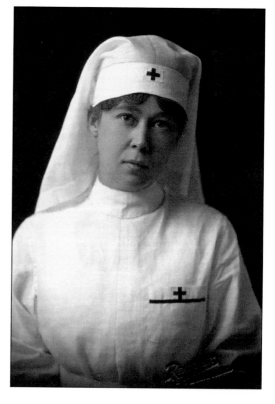

BESSIE LINDSEY, 1918. Shown here in a World War I Red Cross uniform, Bessie Lindsey was an outstanding member of the Forsyth community. She wrote several books on antique glassware as well as a history of Long Creek. She was active in the Illinois Daughters of the American Revolution (DAR), and she published articles in several national magazines. (Courtesy of Decatur Public Library.)

BESSIE LINDSEY, 1920. On her 15th wedding anniversary, September 14, 1920, Bessie Lindsey was photographed in her back yard on Ruehl Street. Socially progressive, Bessie Lindsey was deeply appreciative of women's rights, including the right to vote. (Courtesy of Rosemary Malone.)

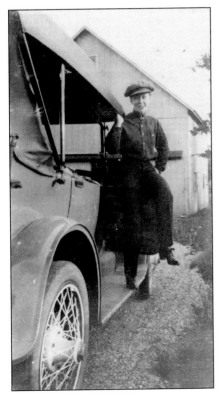

BESSIE LINDSEY ON TOURING CAR, 1920. Bessie is clowning around in this photograph, probably taken by her husband. She is wearing men's clothes and smoking a cigarette. The more daring and modern women were beginning to smoke in public at this time, and the Jazz Age was about to begin. (Courtesy of Rosemary Malone.)

DR. LUCIEN NELSON LINDSEY AT HOME, 1920.
Bessie Lindsey probably took this picture of her
husband in their front yard on Ruehl Street.
Dr. Lindsey was very active in the social and cultural
life of Forsyth, where he was well known and respected
as the town doctor. (Courtesy of Rosemary Malone.)

FREEDOM

Freedom is the gift of God
Permitting all to choose
Lives of virtue—and—as well
Unworthy things refuse.

As we look at records true
That show a nation's past,
All that did not choose the right
Lost dear—bought freedom, fast.

If we, of the U.S.A.
This blessing would retain,
Nothing less than moral law
Will this intent maintain.

Tyranny's defiance would
Destroy man's dearest right—
Eternal vigilance, and worth
Hold freedom's hallowed light.

Bessie M. Lindsey

BESSIE LINDSEY'S FREEDOM POEM. An
accomplished author, Bessie Lindsey worked in
several genres of writing, including poetry. This
poem from the World War I era, with its theme of
freedom versus tyranny, is still appropriate today.
(Courtesy of Rosemary Malone.)

Four

THE EASTERN TOWNS, MOUNT ZION, AND MACON

Argenta and Oreana were named respectively for silver and gold. Argenta was part of a cluster of three closely linked villages, including Dantown and Newburg. Dantown was known for its distilleries and Newburg for its fresh produce and groceries. In 1843, Argenta's Presbyterian Church was founded. In nearby Oreana, a schoolhouse had been erected in 1841, after the arrival of early settlers Samuel T. Miles and J. T. Stevens. In 1858, Dr. H. C. Johns, the husband of Jane Johns, opened a tile factory there. The Oreana Baptist Church was founded in 1858, and the Oreana Christian Church in 1860.

James Howell of Ohio was the first settler to arrive in Oakley Township. Other early settlers included John Hizer and John Rea, both of Virginia, William Grason from Ireland, and Jacob Seitz from Germany. Oakley Village was platted by William Rea in 1856. Oakley was on the Wabash Railroad, and in 1867 J. B. Spangler opened a blacksmith shop there. Simon P. Nickey and Moses A. Nickey were influential Oakley farmers around 1900.

The first settlers in Long Creek were William Baker and David Davis, a judge, in 1828. Joseph Spangler came in 1835, and Thomas Warfield bred horses there after 1845. Long Creek was platted in 1882, but a post office had existed there as early as 1875. Long Creek and nearby Casner Station (founded in 1877) were on the Cincinnati, Hamilton, and Dayton Railroad.

Mount Zion had a Presbyterian Church by 1830. The Bethlehem Cumberland Presbyterian Church was built in 1850 and the North Fork Cumberland Presbyterian Church in 1855. Mount Zion was platted by S. K. Smith in 1860. Incorporated in 1881, Mount Zion is now the most rapidly growing town in the county and has an excellent school system.

Elwin has always provided a convenient way station between Decatur, Mount Zion, and Macon. Macon was founded in 1854, and the Illinois Central arrived there in 1860. Beyond Macon lies the hamlet of Walker, the last settlement before the end of Macon County.

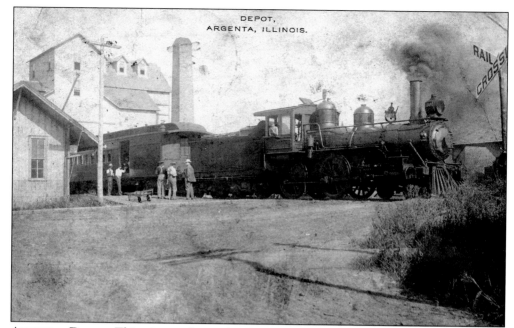

ARGENTA DEPOT. This picture shows the Argenta Depot, with the grain elevator in the background and a puffing locomotive in the foreground. The men are standing around and chatting before the train departs and continues on its journey. (Courtesy of Pat Riley.)

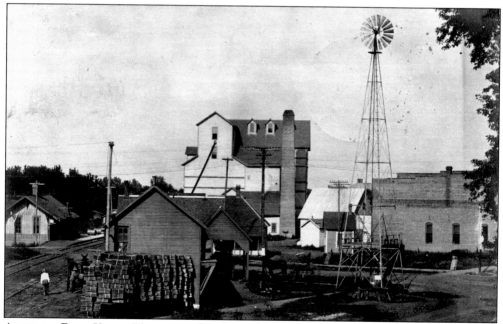

ARGENTA RAIL YARD. The rail yard with its depot, windmill, horse and buggy, and neatly stacked materials seems to be very efficiently organized. This photograph is one of the earliest surviving images of Argenta, dating to about 1905. (Courtesy of Pat Riley.)

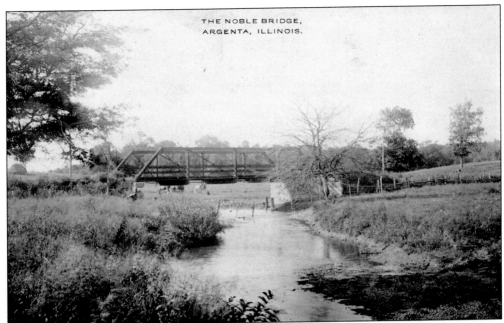

THE NOBLE BRIDGE,
ARGENTA, ILLINOIS.

NOBLE BRIDGE, ARGENTA. Although this pastoral scene resembles a stream in the south of England, it is actually Friends Creek in the northwest part of Macon County, where the creek is traversed by the Noble Bridge. The photograph was taken about 1910. (Courtesy of Pat Riley.)

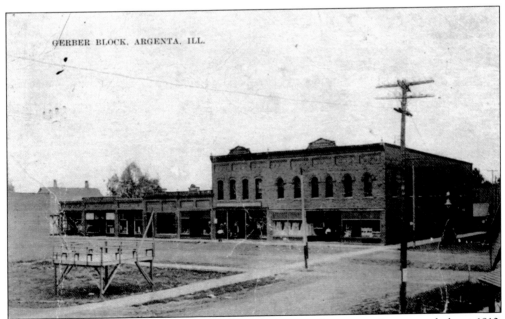

GERBER BLOCK, ARGENTA, ILL.

GERBER BLOCK, ARGENTA. This scene shows downtown Argenta as it appeared about 1910. The reviewing stand on the left-hand side of the photograph suggests a parade or assembly had recently occurred—or was just about to happen. (Courtesy of Pat Riley.)

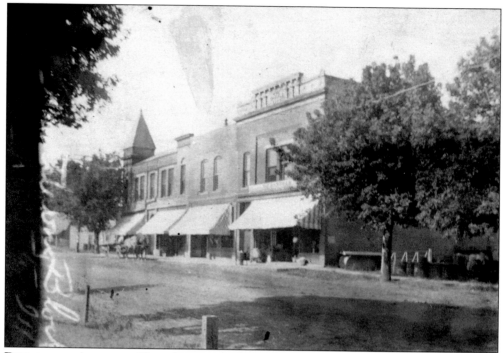

DOWNTOWN ARGENTA. This photograph shows another view of downtown Argenta about 1915. A team of horses is pulling a wagon on a cool day as a man in a heavy jacket ambles down the sidewalk. (Courtesy of Pat Riley.)

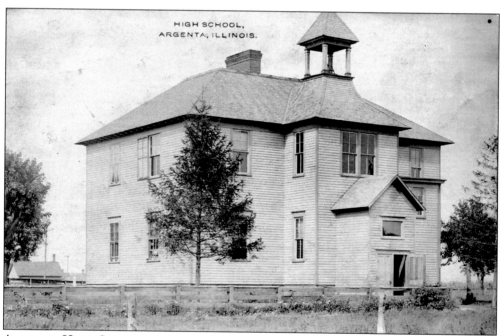

ARGENTA HIGH SCHOOL, 1908. As Macon County grew and became more prosperous, brick buildings eventually replaced all the wooden high schools, and all the one-room schools disappeared, as school districts merged with one another. (Courtesy of Pat Riley.)

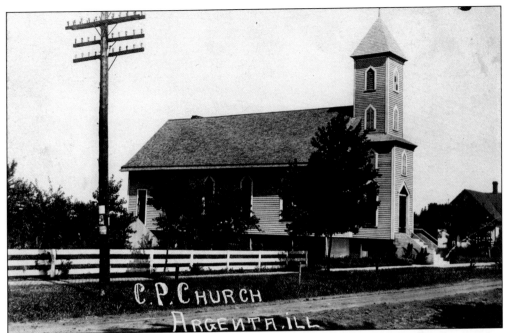

CUMBERLAND PRESBYTERIAN CHURCH OF ARGENTA. The Cumberland Presbyterians were a denomination with considerable strength in Kentucky and Tennessee. Organized on the east coast in 1806, the Cumberland branch merged with the Presbyterian Church, U.S.A. in 1910, about the same year this wooden church was photographed. (Courtesy of Pat Riley.)

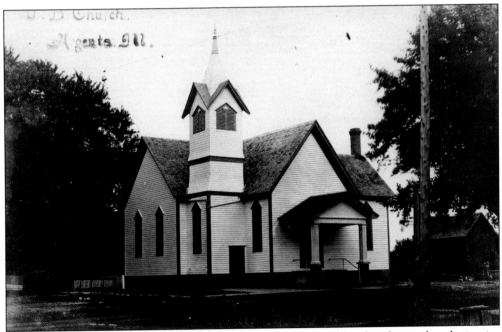

UNITED BRETHREN CHURCH, ARGENTA, 1912. This cottage-like church is rather distinctive in style with its contrasting trim, abundant use of shingles, and unique front porch extending over the entranceway. Note the barn standing to the right. (Courtesy of Pat Riley.)

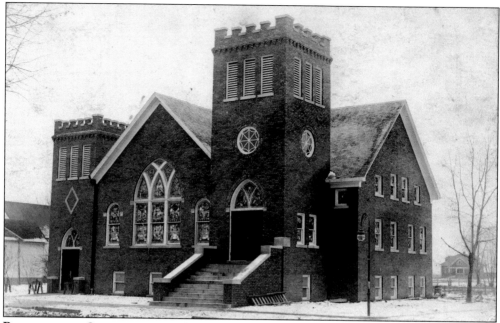

PRESBYTERIAN CHURCH, 1913. This large, brick church, with a magnificent array of stained glass windows, was photographed on a bleak winter day in 1913. Note the sawhorse on the left side of the church and the ladder on the right side of the front steps, indications of recent work. (Courtesy of Pat Riley.)

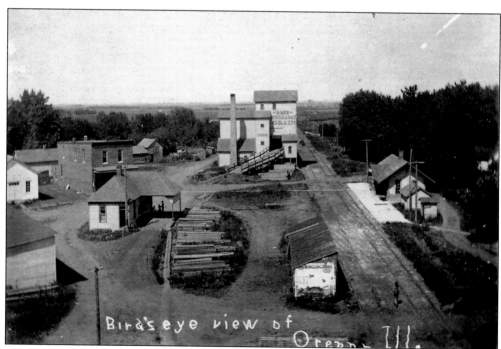

BIRD'S-EYE VIEW OF OREANA. The Ross-Hockaday grain elevator is the tallest building in this picture, taken about 1910. The painted sign on the wall of the shed in the foreground reads, "Ringling Bros.—World's Greatest Shows." (Courtesy of Pat Riley.)

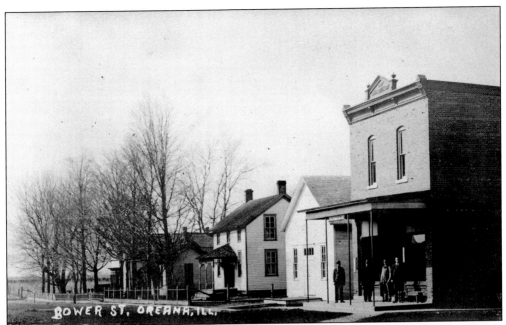

BOWER STREET, OREANA. From the appearance of the bare tree branches, this photograph was probably taken in the spring or fall about 1915. The wide porch in front of the store offered an excellent place to gather and gossip, as men did in similar venues all over Macon County. (Courtesy of Larry Nix.)

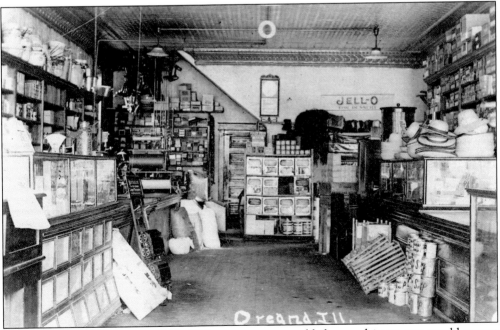

OREANA GENERAL STORE, 1912. This country store sold the usual items one would expect to find, including Jell-O, straw hats, buckets of paint, and kitchen utensils. Once the railroads arrived in 1954, consumer goods of all kinds became more and more widely available throughout Macon County. (Courtesy of Larry Nix.)

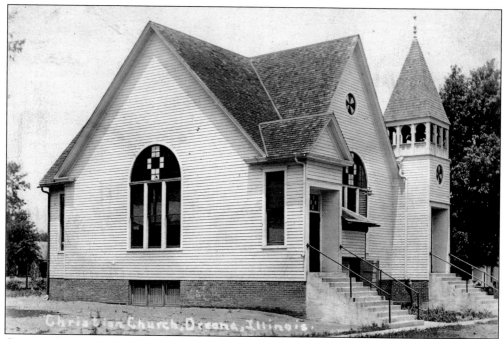

OREANA CHRISTIAN CHURCH. The architecture of the Oreana Christian Church is a pleasing blend of traditional and modern styles, including a freestanding cupola, or bell-tower, and a generous use of stained glass in the rounded Romanesque windows. (Courtesy of Pat Riley.)

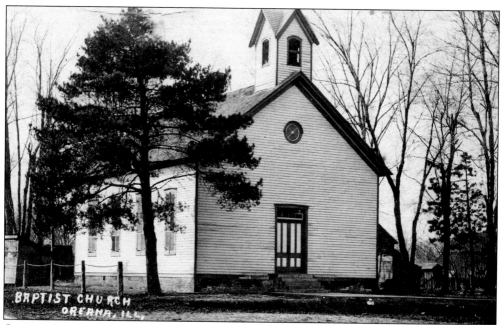

OREANA BAPTIST CHURCH, 1911. A simple rectangular building, this church has a small bell tower perched like an afterthought on the peak of its roof. The Baptists became the largest denomination in Macon County during the 1960s. (Courtesy of Pat Riley.)

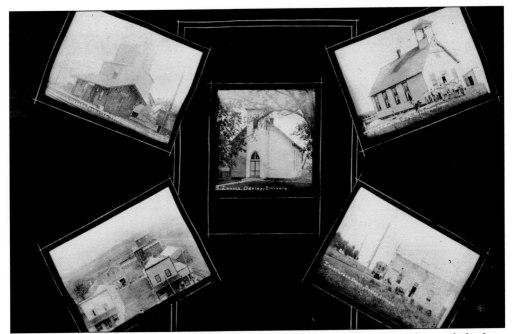

PANORAMA OF OAKLEY. These photographs show important Oakley sights. They include, from left to right, clockwise, the Wabash Depot and Farmer's Grain Elevator, the United Brethren Church (center), the Oakley School with pupils and Mabel Knight (teacher), the interurban Depot, and a bird's-eye view of the whole town around 1905. (Courtesy of Pat Riley.)

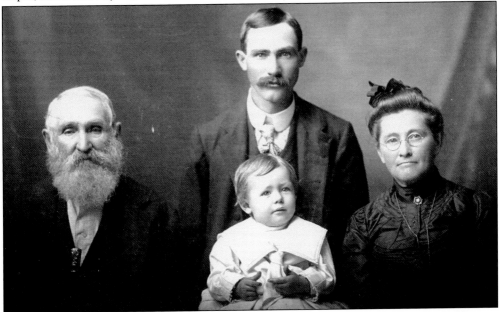

SIMON P. NICKEY AND FAMILY. Simon P. Nickey, the white-haired man on the left, and his son Moses A. Nickey, the dark-haired man in the center, were two of the most important farmers in Oakley when this portrait was made about 1905. The lady on the right is not identified, and the little boy, although unidentified, is probably Moses's son and thus Simon's grandson. (Courtesy of Decatur Public Library.)

BERRY SCHOOL, OAKLEY TOWNSHIP, 1901. Teacher Ezra Frantz presented each one of his 65 students with this souvenir card at the close of the school term in 1901. Remarkably many of these school souvenirs have survived, finding a niche in family archives or scrapbooks. (Courtesy of Pat Riley.)

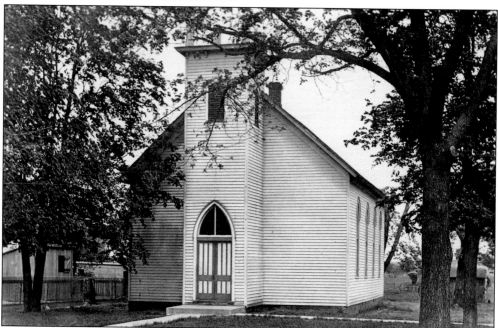

UNITED BRETHREN CHURCH OF OAKLEY. The United Brethren Church of Oakley was a very simple but inviting little church with its paved sidewalk and Gothic entranceway. To the right and rear of the church a buggy is parked, possibly for the use of the pastor. (Courtesy of Larry Nix.)

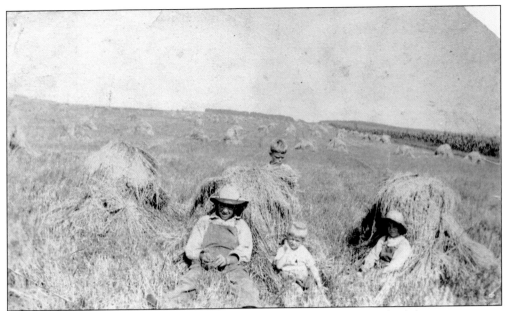

RESTING AFTER THE WHEAT HARVEST. Valentine Nix, the man on the left, rests against a shock of wheat. The three tenants' children are, from left to right, Maurice ?, Matthew ?, and Mary Ann ?, who is wearing a hat. The picture was taken about 1940. (Courtesy of Larry Nix.)

MOUNT ZION GREETING CARD. Only three of these small pictures can be identified. At top right is the Cumberland Presbyterian Church; at center right is Main Street; at center left is the Mount Zion Bank; and the remaining pictures are images of personal residences. (Courtesy of Pat Riley.)

ODD FELLOWS BUILDING. Originally built for the Independent Order of Odd Fellows, this building in the heart of old Mount Zion was used as a furniture store for many years. It is still standing today, right across the street from the current site of the post office. (Courtesy of Pat Riley.)

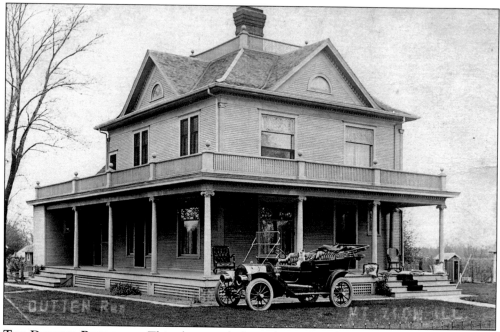

THE DUTTEN RESIDENCE. This photograph from about 1910 shows the tasteful and spacious Dutten residence. A Buick touring car is parked in front of the house, with a dog on the front seat. The house is still standing today, although the area has been developed considerably. (Courtesy of Pat Riley.)

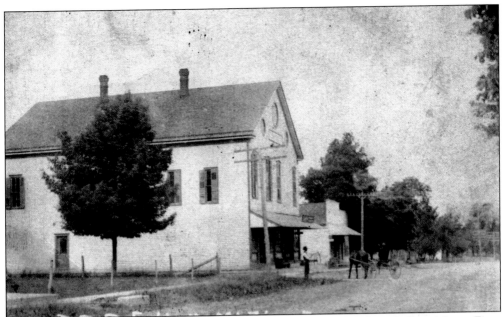

Odd Fellows Hall. This building served as the original Odd Fellows hall in Mount Zion, and the photograph was taken just before the Ford Model Ts, or the Flivvers and Tin Lizzies, as they were known, began to appear. The Odd Fellows were one of several fraternal organizations active in the county, including the Knights Templar, the Masons, the Knights of Columbus, and the Knights of Pithias. (Courtesy of Pat Riley.)

Lover's Lane, Mount Zion. This card depicts a generic scene. It was sold widely with the name of the town changed for each new marketing area. However, real lover's lanes did exist throughout rural America, even in the prim days leading up to World War I. (Courtesy of Pat Riley.)

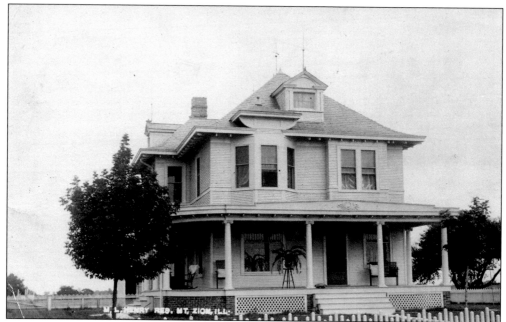

M. L. HENRY RESIDENCE. The M. L. Henry house was an attractive, three-story dwelling with dormer windows and wrap-around porches, evidence of a comfortable middle-class lifestyle. The photograph is dated August 1909. (Courtesy of Pat Riley.)

With Best Wishes

From Your Teacher

SALEM SCHOOL, MOUNT ZION, 1908. Teacher Annie B. Florey handed out this souvenir booklet to all 43 of her students on May 7, 1908. Many members of the same families were in the class, like Leeta and Florence Casner, Ruth and Ethel Floyd, Pearl and Ray Nowlin, and Grace and Cecil Dearman. (Courtesy of Pat Riley.)

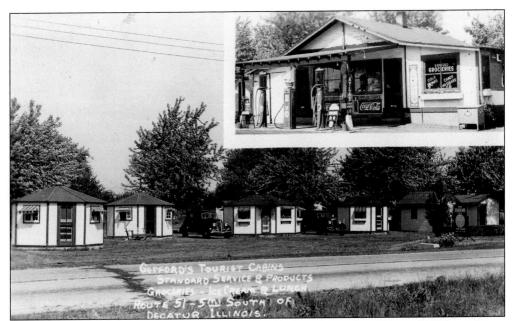

GEPFORD'S TOURIST CABINS. Tourist cabins were all the rage in the 1920s and 1930s, and were the forerunners of today's motels. Gepford's was located between Decatur and Elwin on U.S. Route 51. The establishment also sold gasoline and groceries. The sedan parked on the left is a 1935 Ford. (Courtesy of Pat Riley.)

MAIN STREET, ELWIN, 1912. Like all the rural communities in Macon County, Elwin had dirt streets, which were dusty in the summer and muddy in the winter. The store on the right side, next to the parked car, sold "groceries, hardware, wire fence, and notions." (Courtesy of Pat Riley.)

MOTEL L-WIN
On U. S. 51
4 miles South of Decatur, Illinois

MOTEL L-WIN. A landmark on U.S. Route 51, the L-Win Motel is still in existence, although it has undergone a metamorphosis and become a mini-mall and tea room, a good example of adaptive reuse in commercial architecture. (Courtesy of Pat Riley.)

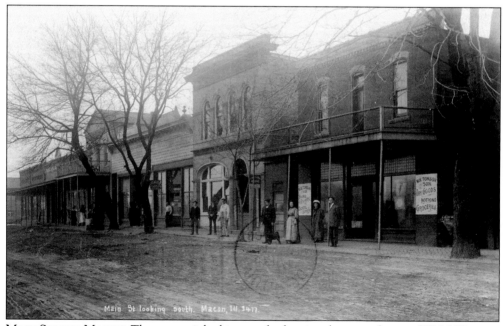

MAIN STREET, MACON. The camera is looking south, showing the general store of W. M. Towson, which sold books, stationery, school supplies, dry goods, notions, and groceries. Townspeople and a black dog stand on the brick sidewalk. J. F. Smith's real estate office is down the block. The photograph was taken about 1910. (Courtesy of Pat Riley.)

PORTRAIT OF THOMAS DAVIS.
Thomas Davis posed in the
Vandeventer Studio of Decatur for
this portrait on September 15, 1909.
He owned the first building in Macon.
He knew Abraham Lincoln, and
he donated the Women's Christian
Temperance Union water fountain,
which stood between the train depots
in Decatur. A school in Macon was
named after him. He died in 1913.
(Courtesy of Decatur Public Library.)

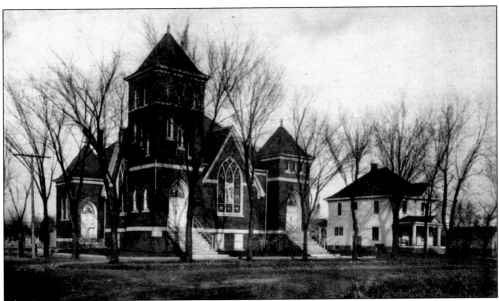

METHODIST EPISCOPAL CHURCH AND PARSONAGE, MACON. This photograph is unusual
because most church photographs do not generally show the parsonage, and most parsonages
are not two-story dwellings like this one. C. U. Williams, a famous Bloomington photographer,
took this picture in 1917. (Courtesy of Pat Riley.)

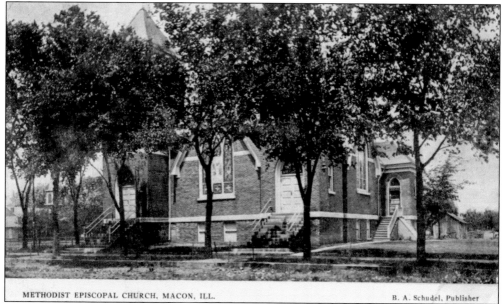

METHODIST EPISCOPAL CHURCH, MACON, ILL.

B. A. Schudel, Publisher

METHODIST EPISCOPAL CHURCH, 1907. The Methodist Episcopal Church of Macon was an imposing structure, nicely situated among hardwood trees. This postcard image was published by B. A. Schudel and actually printed in Germany, a practice that came to a sudden halt just before World War I. (Courtesy of Pat Riley.)

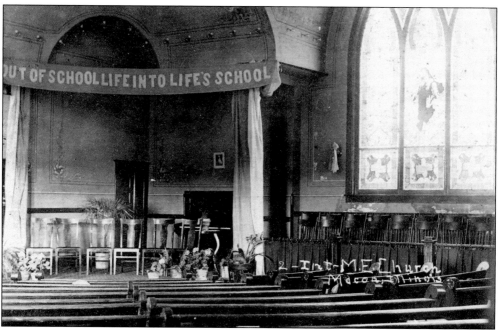

INTERIOR OF METHODIST CHURCH. This photograph is a rare interior shot of a church, as most photographers did not—or could not—venture into the sanctuary. The banner over the altar reads, "Out of school life into life's school," and may have been used with a graduation celebration. (Courtesy of Pat Riley.)

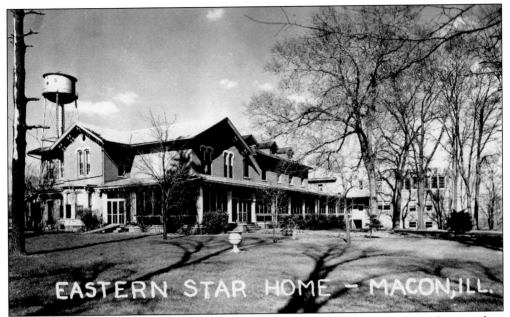

EASTERN STAR HOME – MACON, ILL.

MASONIC AND EASTERN STAR HOME, MACON. This sanitarium and rest home has stood on the east side of Macon, near present U.S. Route 51, for almost a century. The photograph was taken about 1950, and the building has been extensively remodeled since that time. (Courtesy of Pat Riley.)

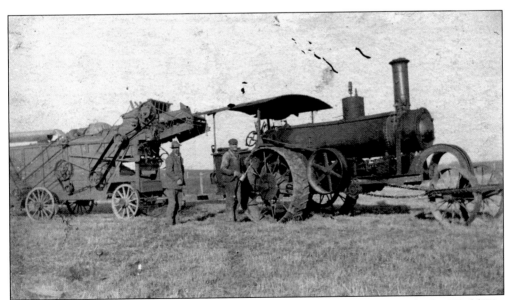

GRAIN THRESHER, MACON. Steam-powered grain threshers were not used much after World War II. This thresher was photographed in 1929, but the machine itself is much older, probably dating to about 1905. The two men in the picture are not identified. (Courtesy of Darren Eckart.)

125

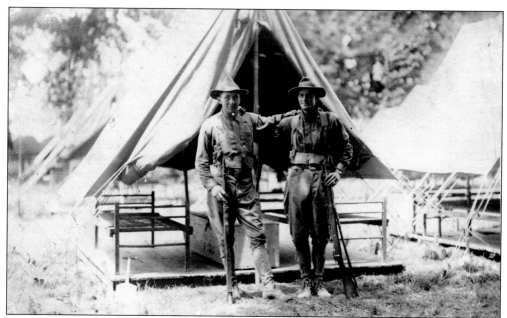

PVT. GEORGE EASTEP. Pvt. George Eastep of Macon is shown here on the left in a photograph taken about 1909. The Illinois trooper on the right is ? McKinley. The two men were on maneuvers, possibly training at Camp Butler outside Springfield. (Courtesy of Darren Eckart.)

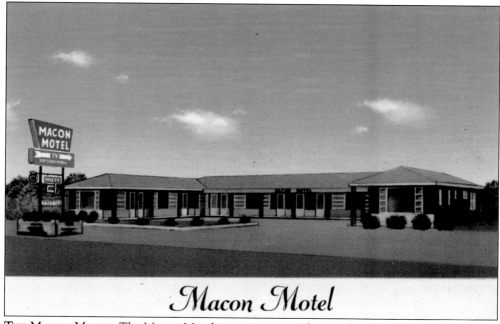

THE MACON MOTEL. The Macon Motel is a quintessential example of locally owned motels in the 1950s before huge corporations built two- and three-story inns containing hundreds of rooms and large parking lots. This lithograph was made about 1960. The motel looks dignified and unassuming, ready to receive the next visitor who has traveled the length of Macon County.

BIBLIOGRAPHY

Atlas of Macon County and the State of Illinois. Chicago: Warner and Beers, 1874.

Coleman, E. T. *History of Decatur and Macon County.* Decatur, IL: Herald Press, 1929.

Gosnell, Virginia. *History of Mt. Zion Community: From the Beginning.* Astoria, IL: Stevens Publishing Company, 1981.

History Book Committee, ed. *Warrensburg: 1882–1982.* Warrensburg, IL: History Book Committee, 1981.

History of Macon County, Illinois. Philadelphia, PA: Brink, McDonough, and Company, 1880.

Letters Written in Macon County: 1829–1864. Typescript. Decatur, IL: Shilling Local History Room, Decatur Public Library.

Lindsey, Bessie M. *Long Creek Township in Macon County, Illinois.* Typescript. Decatur, IL: Shilling Local History Room, Decatur Public Library, 1932.

Macon, Illinois County Directory. Algona, IA: Directory Service Company, 1975.

Past and Present of the City of Decatur and Macon County. Chicago: S. J. Clarke Publishing Company, 1903.

Stoutenborough, Mrs. Roy, and Mrs. George Gentle, eds. *Maroa Centennial Photo Album.* Maroa, IL: Maroa Centennial Committee, 1954.

White, Florence. *Rural Schools of Macon County.* Decatur, IL: Macon County Historical Society, 1978.

Discover Thousands of Local History Books
Featuring Millions of Vintage Images

Arcadia Publishing, the leading local history publisher in the United States, is committed to making history accessible and meaningful through publishing books that celebrate and preserve the heritage of America's people and places.

Find more books like this at
www.arcadiapublishing.com

Search for your hometown history, your old stomping grounds, and even your favorite sports team.